J. Blumberg

OIL PAINTING:

TECHNIQUES AND MATERIALS

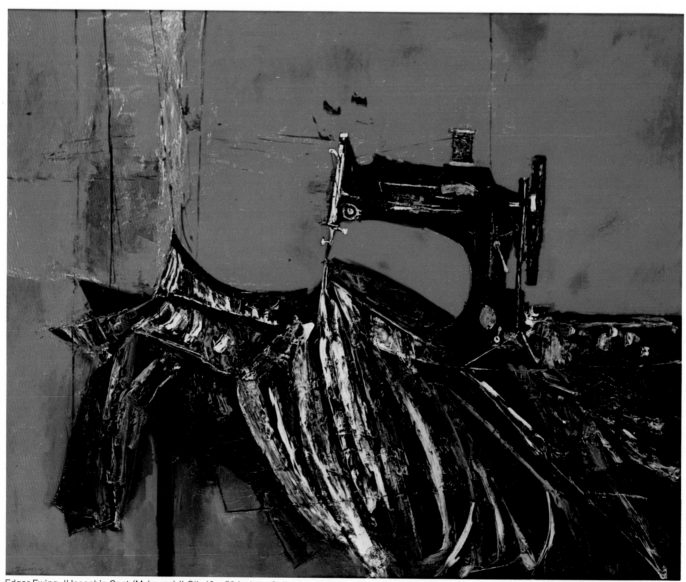

Edgar Ewing, ''Joseph's Coat (Mykonos).'' Oil, 40 x 50 inches. Collection of Mr. and Mrs. John L. Grant. Photo by Delmore E. Scott. Courtesy Esther Bear Gallery.

Joseph Mugnaini

OIL PAINTING:

TECHNIQUES AND MATERIALS

VNR VAN NOSTRAND REINHOLD COMPANY
NEW YORK CINCINNATI TORONTO LONDON MELBOURNE

This one is for two: Diana and Damon

Designed by Jean Callan King.

Published by arrangement with
Van Nostrand Reinhold Company,
450 West 33rd Street, New York, N.Y. 10001.

I want to express my thanks to Ruth, whose
critical appraisal of the book in its formative
state influenced the shaping of its format and
the direction of its thought; to Eddie Jung,
whose photographs constitute the bulk of its
illustrations; to George DeGroat and Gene
Coon for lucid comments which helped to
maintain consistency within a vast and diffi-
cult subject. I am indebted to Norman Tyre
and George Dighera for photographing cer-
tain important sections, and to Benjamin
Horowitz, the Heritage and Orlando Galleries,
who generously allowed me to reproduce
work especially applicable to the text; to the
Board of Governors and the administration of
the Otis Art Institute of Los Angeles County
for allowing me to use the school facilities; to
the Museum of Modern Art, the Whitney
Museum of American Art, and the Metropoli-
tan Museum of Art of New York City and the
National Gallery of Art and the Phillips Collec-
tion of Washington, D.C., for permission to
reproduce work from their priceless collec-
tions; to *Ramparts* magazine for permission
to reproduce the work by Norman Rockwell;
and finally to my students, from whom I am
constantly learning.

Preface

My first remembrance of a summer night is when, as a boy, I lay in the grass listening to the sound of crickets while watching the stars. What I saw and heard that night seemed so vividly intense that sight and sound became fused in my memory as a single experience. Now on summer evenings, listening with eyes closed, the bright sound of crickets is to me a sound pattern of starlight, and on cool winter evenings, when crickets sleep, the sharp staccato brilliance of a starry sky is to me a luminous version of cricket sounds.

There are moments in our lives when an experience may become so indelibly impressed into the fabric of our consciousness that it permanently influences all future experiences of a similar nature. A work of art can produce such moments, during which the experience of the artist is communicated to the viewer. I know that I shall always find myself momentarily quarreling with nature whenever I see in the bright face of a sunflower an imitation of a more vigorous prototype painted by Van Gogh. I shall always become impatient with myself when the abstract beauty of a sunset seems to have been exclusively created for the convenience of William Turner.

Art has the power to awaken and resensitize the blunted consciousness of man, to make him aware of that which cannot be perceived through sight alone—the murmur of life in a starry expanse of sky, the vastness and mystery of space in the sounds of a summer night.

Joseph Mugnaini

Contents

Introduction

I have tried many times to reconstruct in my imagination the beginning of art. I always end up with the same scene—perhaps because the sequence of events seems so inevitable, at least to me, that other possibilities are excluded. It could have happened as I see it . . .

A lone figure moving about in pre-dawn darkness paused, then stood motionless, eyes fixed on an expanding halo of light edging steadily over the horizon. He remained motionless, mesmerized by the increasing brightness, until the intense light of the rising sun forced his eyes to close.

Yet, strangely, he could not shut out the image. It persisted as a blue-white disk, glowing against the warm transparency of his eyelids. Impulsively he reached out to touch it, hand moving futilely in empty space. Then,

This book is based on the constant search of the artist for the medium and technique that he can use to express himself. My purpose is to guide students to their own individual methods, to share information that I consider valuable with all those engaged in painting, and to assist those who simply wish to increase their appreciation of painting. Consequently, I have concentrated on those elements of painting that are essential to all the visual arts, regardless of period or style. As in an illustrated lecture, comparisons are made between the works of artists living and dead in order to identify qualities that are common to all paintings. To this end, the works used in this book were selected to illustrate the logic behind the visual arts in general, not to prescribe specific techniques —technique in any case cannot be acquired but must be generated from within and allowed to develop as an extension of the artist.

Although the material presented here is self-contained, it can be used with other books and with reproductions of paintings that the reader may own or be able to obtain. Oil paintings and the techniques of oil painting are emphasized in the discussions and demonstrations because this medium possesses the qualities of the other media as well as having unique qualities of its own, and the principles behind oil painting can be applied to paintings done in other media. I have presented the material as a teacher would. For example, the exercise in the first chapter, in which two paintings are compared, is designed to make a student out of the reader— and a student should be confronted with a problem and allowed to contend with it on his own before he is presented with a solution.

failing, he lowered his head. Reopening his eyes, he saw that the bright burning disk lay within easy reach at his feet. He knelt, thrust his fingers into the soft earth, and probed with circular motions. Without being aware of it he had shaped the image of the sun, rendered in the shadow of its own light. At this moment, the inherent restlessness of man emerged— and the boundless vision of art was born.

Thus the first art was realized in the most elemental of media, the earth itself, with the most elemental of tools, the hand of man. The result was neither painting, drawing, nor sculpture. But it was the root of all visual art; it contained what all significant art does. It was an artifact born of a struggle to understand the unknown, to realize and express intangibles beyond total comprehension.

Part I. The Theory

1 The Elements of Art

Painting, like music and literature, has a language of its own. Its language is based upon visual elements—line, tone, space, dynamics, color, texture. The objective of this book is to isolate and examine these elements, relating them to basic methods and materials used in the visual arts. After this sort of study the reader should be able to coordinate his own motives and philosophy with a suitable medium and technique.

The book of Genesis describes the creation of man—form—as a work of art which involved elements of mind, method, and material. Man's concept of his own creation has been modified since Genesis was written, but his concept of creation itself is fundamentally the same. Art, finding its source within man's consciousness, has maintained even during its periods of greatest change universal elements in its imagery and essentially the same materials and techniques. Even today, when art is exploring new areas of thought, the artist is still primarily concerned with the perennial challenge of his material and methods of controlling it.

It is unfortunate that many laymen, a great number of artists, and too many critics consider the skillful manipulation of material to be the most essential of the factors involved in a work of art. The truth is that intent, control, and media are all equally important, equally indispensable; in the development of a work of art they become fused. The artist views "talent" as the ability to combine intangibles of the mind and physical properties of material into a work of art, and "technique" as the individual manner in which this is accomplished.

This rather general introduction to the subject of the elements of painting can be illustrated by Chaim Soutine's "Windy Day, Auxerre," on page 13. Before proceeding to my own comments, the reader should examine it for himself, asking himself how the artist used materials and elements and why he used them the way he did.

This painting, like others by Soutine, stimulates a strong tactile response. In fact, one might close one's eyes and actually feel within the matrix of hardened pigment the results of emotional reaction. (See the example of this technique, *B,* in the illustration on page 37.) For the subject of this painting is not purely a landscape. The real intent of the artist was to translate into thick, freshly applied pigment a personal reaction to an observed or remembered event. What is visible here neither depicts nor attempts to interpret physical reality; it is rather a declaration rising from an intense emotional experience. The medium could only have been oils, for they possess, along with many other remarkable qualities, the density and versatility required for a painter to register the repertoire of brush pressures and movements which are evident in this painting. The method used is typical of Expressionism, in which the artist seeks to establish a relationship between intuitive imagery and a spontaneous method of painting. The distinguishing feature in this work, however, is the calligraphic method in which it was handled, as though the statement had been written upon the surface of the canvas in a casual, uninterrupted scrawl. The evidence is so obvious that even with little or no training as a painter one should be able to trace the evolution of ''Windy Day, Auxerre'' without difficulty. The following observation on technique is offered not as the single correct analysis, but as a reference to help the reader develop his own conclusions.

The bold and permanently *wet* appearance of the stroke patterns in this painting suggest that it was completed in a continuous operation. This reasoning is based on the nature of oil paint and its normal reaction when handled briskly within a confined area such as this. As

most of us know, when various colors are maneuvered into one another, as in this painting, a critical point at which even the slightest touch will transmute a brilliant clean passage of color into a neutral grey muddiness is soon reached. But even in this black-and-white reproduction it can be seen that the pigments have been kept at optimum clarity, showing that the painter adjusted the action of his painting to the nature of his material.

This approach may be compared to the act of walking a tightrope. The performer, after carefully gauging the distance of his proposed movement into space, establishes an equilibrium; then, following a few short probing steps, steadily increases his momentum until he reaches his destination. Soutine, sensing a rapport between his exploratory applications of pigment and a subconscious image, reinforced the pattern with added strokes. Then, increasing his pace, he simultaneously developed shape and "counter-shape" of trees, sky, and earth, terminating with the brisk yet sensitively applied swirling movements representing the mass of leaves within the grouping of trees. There is no doubt that the maintenance of a momentum was the key to the success of this painting.

At this point we can see that graphic art in general and painting in particular depend on the visual elements—line, tone, texture, space, color, and dynamics. That these elements transcend time and style becomes even more evident if we compare Soutine's painting with "John, Duke of Saxony" by Lucas Cranach the Elder, on page 15.

Chaim Soutine, "Windy Day, Auxerre" (1939). Oil on canvas, 19¼ x 25⅝ inches. The Phillips Collection, Washington, D. C.

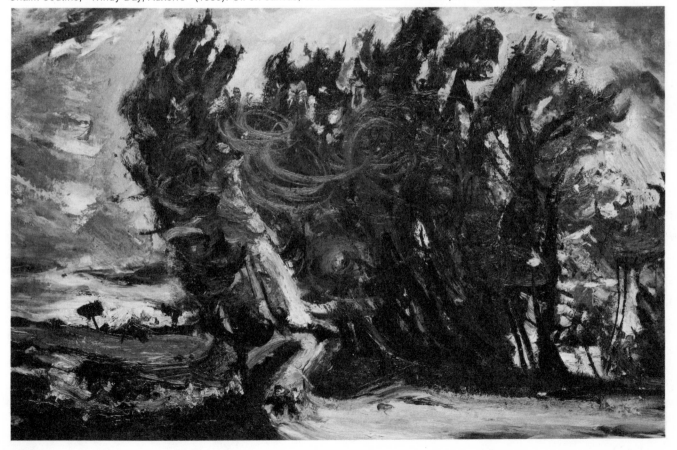

In comparing these two paintings we discover that the differences result from the special graphic vocabulary of each artist—in each case a vocabulary within a visual language with which all of us are either consciously or subconsciously familiar.

1. The element of tonality is prominent in both paintings and extends over the full range, from extreme light to extreme dark.

2. The element of line is inconspicuously incorporated into the design of the large areas of the Cranach, but obviously stated in the dynamic brush strokes and distorted imagery of the Soutine.

3. The texture in the Cranach is carefully applied, smooth and transparent, while that of the Soutine is agitated and thick.

4. The dynamics of the Cranach are quietly controlled by the use of large, simply stated areas which seem to project toward the viewer in the light passages and to recede in the darker areas. In the Soutine, however, the dynamics are evident not only in the animated and distorted shapes, but also in the lateral, vertical, and swirling application of the pigment upon the surface of the canvas.

5. The material—oils in both paintings—is totally subordinated in the Cranach to create an illusion of depth, contour, and spatial reality. In the Soutine the textural eloquence of oil pigment is as important as the imagery.

We must conclude, then, that since the elements of tone, line, color, texture, dynamics, and material are present in both compositions, the differences between these two works are the result of the way these elements were used.

The visual elements of art are the result of neither arbitrary selection nor accidental adoption, for their eloquence and significance arise from man's view of nature, in both the psychological and the physical sense. It is through the sense of touch that we first become acquainted with the form of nature. At a very early age, through tactile experience, we become aware of edges, planes, contours, and textures, steadily gaining familiarity not only with form but with the space that surrounds it. Later, during the development of our sense of sight, we begin to identify and associate concepts acquired through the sense of touch with their visual counterparts. We eventually learn either consciously or subconsciously that the two sensory devices carry related information. For example, an object that feels contoured, extremely smooth, and hard will be seen as a highlight surrounded with gradually changing tones, yet both sensory systems are conveying information regarding a *hard rounded surface.* The undulating contour of a pear, an expanding and diminishing mass, may be "seen" by the hand and "felt" by the eye. Thus it is possible to feel tonality and line just as it is to see mass, texture, and contour.

Lucas Cranach the Elder (German, 1472-1553), "John, Duke of Saxony" (died 1537). Tempera and oil on wood, 25⅝ x 17⅜ inches. The Metropolitan Museum of Art, Rogers Fund, 1968.

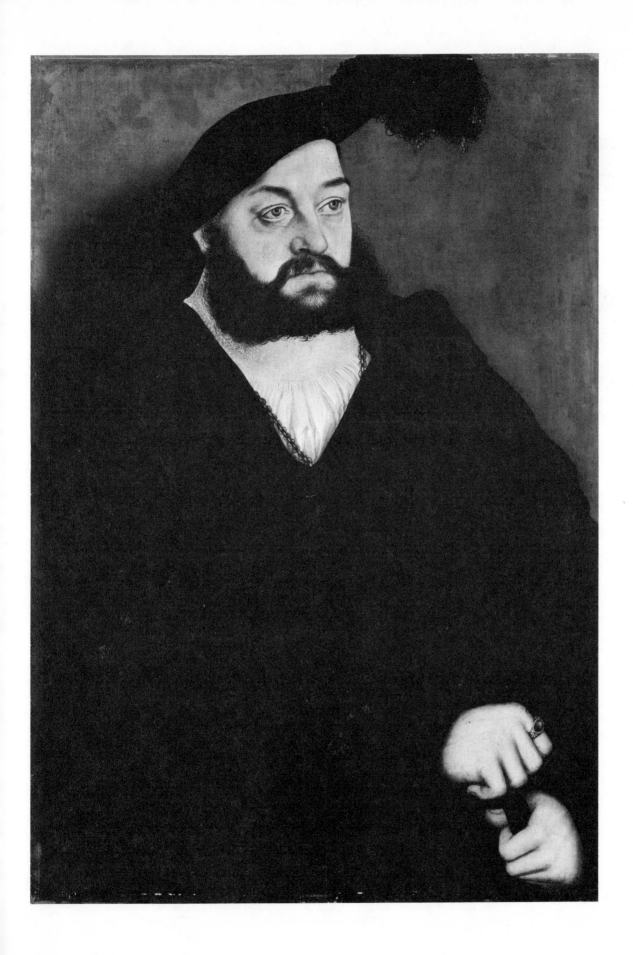

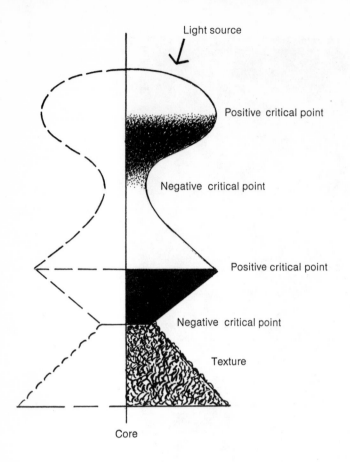

Light source

Positive critical point

Negative critical point

Positive critical point

Negative critical point

Texture

Core

The drawing shows how form in space is represented visually through line and tone.

Form may be visualized as advancing and retreating, or receding, in space. In a symmetrical shape, line and tone (contour and shadow in nature) are synchronized to express the increasing and diminishing mass seen in its frontal aspect. The same increasing and diminishing mass viewed in profile is expressed in line. Both line and tone reach critical points before reversing their trend. A critical point is either positive (the extreme point of extension away from the core or nucleus of the form) or negative (the extreme point of retreat toward the core or nucleus). At each critical point, line and tone reverse their trends, expanding or receding in the case of line, becoming lighter or darker in the case of tone. Compare the sharp differentiation of tone, synchronized with the sharp reversal of line, in the lower half of the form with the more gradual progression of each in the upper half. These means of interpreting form and space influence all works of art directly or indirectly.

Techniques of expressing form are particularly evident in sculptors' studies. Soutar's intent in his pen-and-ink study was to think of his pen as a chisel and the paper as a piece of solid material, conceivably a piece of white marble, in which tone gradually appeared as marble was cut away. To the sculptor the white areas in this drawing represent solidity within the figure and emptiness in the surrounding areas. Various tones indicate the depth, slope edges of planes, projections, and apertures, for a sculptor is involved with mass, volume, movement (dynamics), and texture as well as subject matter.

16

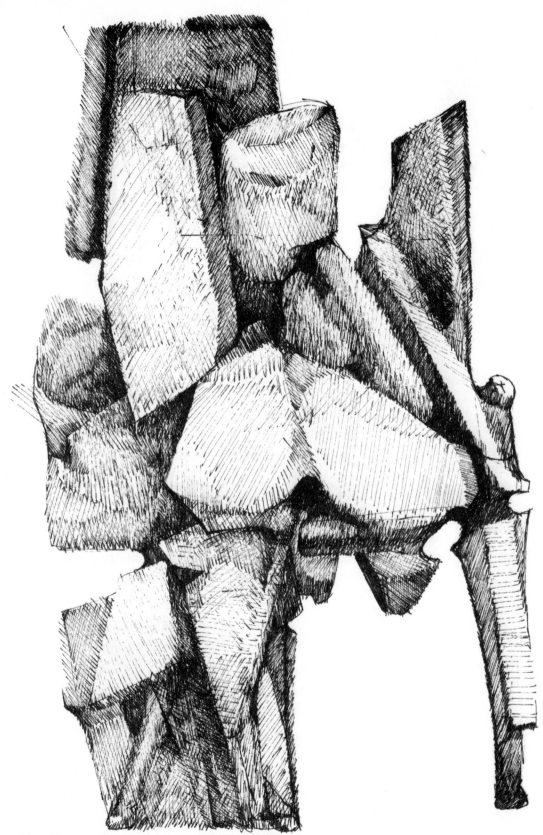

Edward Soutar, "Drawing for Sculpture." Pen and ink.

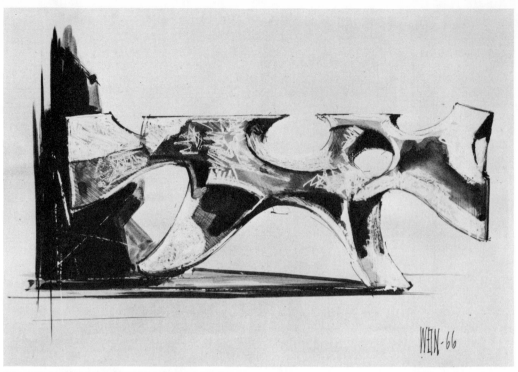

Albert Wein, "Study for Sculpture." Ink and wash.

Albert Wein's ink-and-wash study is an excellent example of a drawing which conveys the spatial, structural, and textural elements of a projected piece of sculpture. One may "feel" the smooth planes and hollows with the eye.

Two of the many possible relationships of line and tone are manifested in the portraits by Norman Rockwell and Ferdinand Bol. Notice how Norman Rockwell clearly establishes a combination of tone and line, limiting the hard-edged contours with the internal structure of each shape. This is an excellent example of the principle of expansion of form discussed earlier.

Although line is subdued in the work by Ferdinand Bol, it is still a strong element in the design. Notice how it reveals itself through the softened edges and muted darks of the tonal patterns.

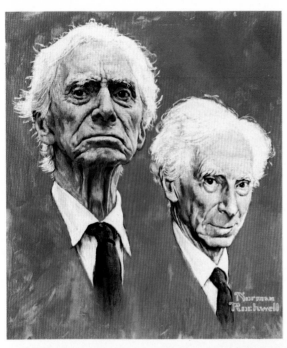

Norman Rockwell, ''Portrait of Bertrand Russell.''
Oil on canvas. Courtesy of *Ramparts* magazine.

Ferdinand Bol, ''The Learned One.'' Oil on canvas.
Collection of H. F. Ahmanson & Company.

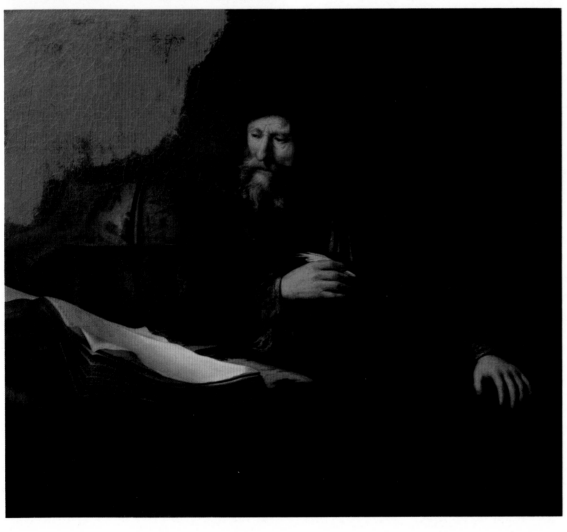

2 Line

Line is the most common and versatile of the visual elements in art. Even though, like the wheel, it is claimed as a human invention, we find it difficult to deny its existence in nature. How can we ignore it in the curvilinear tendrils of a vine, or in the radiating symmetry of a spider web, or even in the finely etched fissures in a stone? Linear direction is implied in a falling drop of rain and in the flight of birds. A concept of line is inherent in most living creatures. For example, the geometric proposition that a straight line is the shortest distance between two points is not only a human abstraction: a lizard follows this principle to escape its enemy.

The concepts of division, containment, and direction are evident in boundaries, fences, and railroads. The first drawings of children are stated in line. The first art was probably conceived in line, incised into the soft earth with a finger or a sharp stick. Simple as it was, it had elements of etching, painting, and sculpture, brought about by the light of the sun and the shadow of newly turned soil.

The illustration on the next page shows several line variations.

The two lines in A are of the same weight and appear at first to be of equal character, yet the top line is drawn with a straightedge while the bottom one is done freely. A closer look reveals that the important difference between the two is not that one is straighter than the other but that the top line is the result of constant pressure while the bottom line shows variation of pressure. In the bottom line we can see that the pen was placed upon the paper at the beginning of the stroke on the left, and lifted at the end of the stroke on the right. The top line was drawn, the bottom line was stroked.

Although B is an abstract linear statement, while C is the drawing of a hand, they have much in common. They both move in a long undulating movement from the left to a convoluted active area on the right. One is abstract and the other is representational, yet both employ line in the same way.

In D our eye moves swiftly from the left, is quietly escorted through the linear passages representing the fingers of a hand, then is returned to its point of origin. Compared with C it is quiet and calm.

The line in E moves swiftly into an excited and active zone, multiplies, is slightly altered, then moves on.

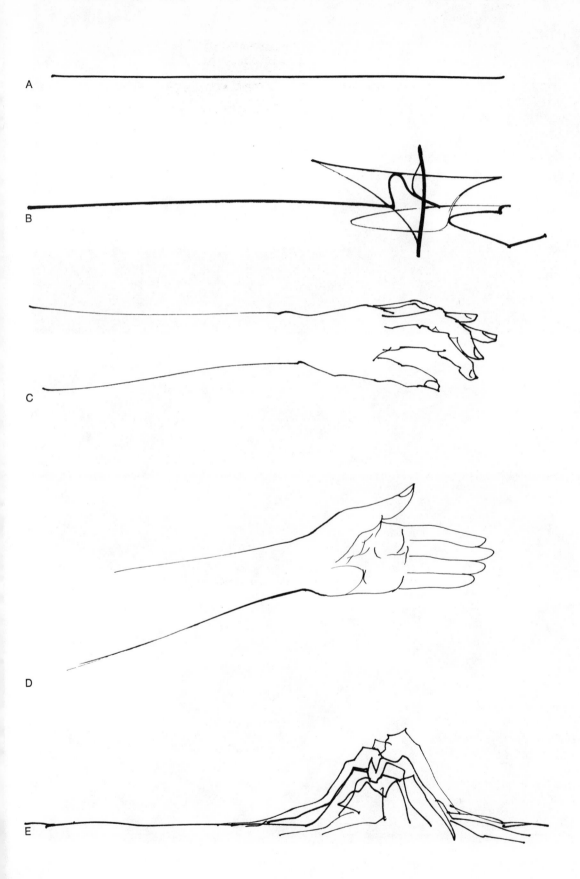

A

B

C

D

E

Flavio Cabral, "Drifting Sorrows." Oil on canvas. Courtesy Heritage Gallery.

Gloria Klissner, "Frances." Oil.

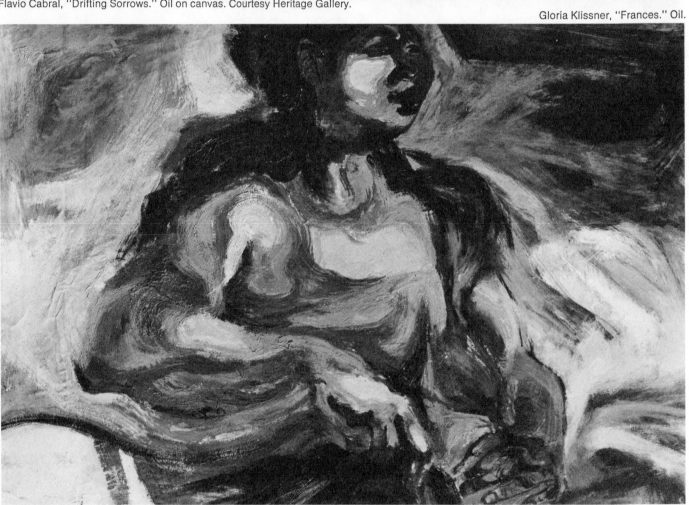

Flavio Cabral describes his approach as follows: "In my work I combine the abstract with the representational. The design is the vehicle into which I place the subject, a series of interlocking, curvilinear shapes, reduced to essentials. The medium is oil, applied flat, building slowly to color nuances through a series of glazes. Concern with resolving the design into a kind of impersonal, absolute statement leads me to emphasize contours."

Line may be planned into a design, as in the work by Cabral, or inadvertently developed, as in Gloria Klissner's work.

We shall see as we proceed that all of the visual elements possess psychological persuasions beyond those that are immediately apparent. The illustration on this page demonstrates this phenomenon.

Both the circles might have been designed to symbolize a familiar shape, such as the moon or an orange, yet the viewer is primarily influenced by psychological factors of greater significance than those related to objective representation. The plotted aspect of the circle on the left, for example, compels the eye to search the circle's periphery for a break, alternately forcing the viewer's attention from its circumference to its interior and away from the surrounding space. The circle on the right, however, bears calligraphic evidence of the instrument, the method, and the time involved in its making. After the eye is attracted to the overlapping ends, it is taken on a journey tracing the path of the pen from the beginning of its stroke through the staccato segment where it skipped to its finale. How an artist exploits such visual devices has an important bearing on his work.

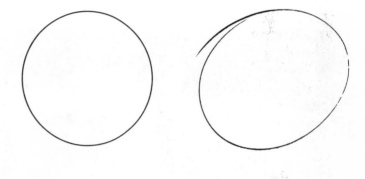

Both of these paintings, one Renaissance and the other contemporary, employ elements common to all art and transcend period and style. Each is extremely tonal in pattern but to a certain degree linear in character, for in these designs linearity is a product of large, relatively simple shapes coming together.

Star O'Breen explains, "With the use of line and spatial interplay I have tried to explore situations both humorous and youthful, using a graphic vocabulary which I feel is reflective of a changing generation."

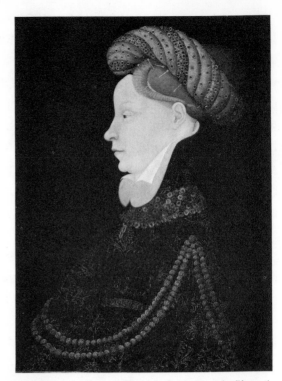

Franco-Flemish School, early fifteenth century, "Profile Portrait of a Lady." Wood, 20⅜ x 14⅜ inches. Andrew Mellon Collection, 1937, National Gallery of Art, Washington, D. C.

Star O'Breen, "Untitled." Acrylic and ink on paper.

Georgia MacLean, "Preying Mantis." Oil, 24 x 30 inches.

Gerald G. Purdy, "Mona Lisa Two-Step Revisited" (1964). Polymer-Tempera, 13½ x 19½ inches.

These paintings by Gerald Purdy and Georgia MacLean also display important linear characteristics. As an experiment, place a piece of transparent paper over each, take a pencil or pen, and using line alone, trace the essentials of the paintings. Which one seems most dependent on line?

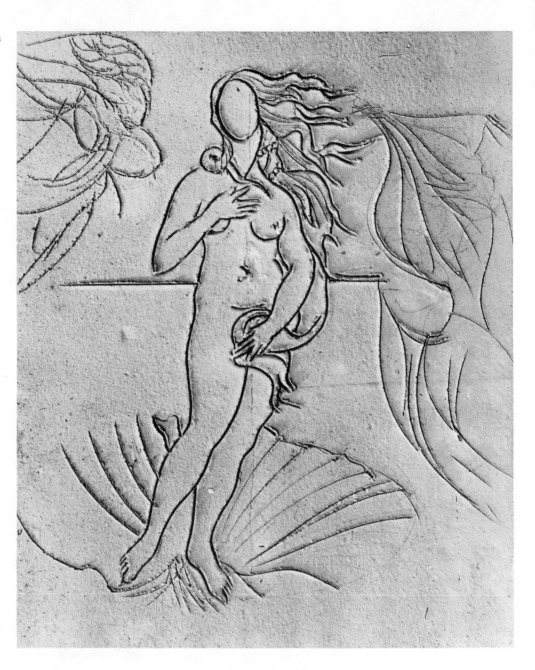

Mud drawing of Botticelli's "The Birth of Venus." Executed by Jean Gilland.

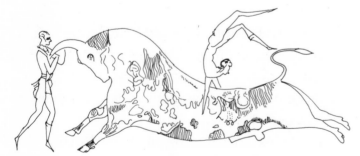

Tracing of the Toreador Fresco, Cretan, about 1500 B.C.

As an experiment, three familiar paintings were rendered in the most basic of materials, mud, using the most elemental visual device, line. The first of the experiments was the mud tracing of a detail of "The Birth of Venus" by Botticelli. It is evident that even though Botticelli used all the basic visual elements, the salient ingredient is line.

Note the formal linear quality of the Cretan Toreador mural and the freely handled, whimsical line of Sidney Cobb. Then compare both with the ''Venus.'' Notice that both the mural and the Botticelli depend upon lyrical, formally contoured shapes contained by line, while the Cobb is sharply stated in a spontaneous, active manner. One can almost hear the scratching of the instrument upon the surface.

The second painting in the mud experiment was ''The Starry Night'' by Vincent Van Gogh. This experiment reveals that Van Gogh's bold and intense color patterns are dependent upon dynamic line.

Sidney Cobb, ''Horses.'' Pen and ink.

Mud drawing of Vincent Van Gogh's ''The Starry Night.''

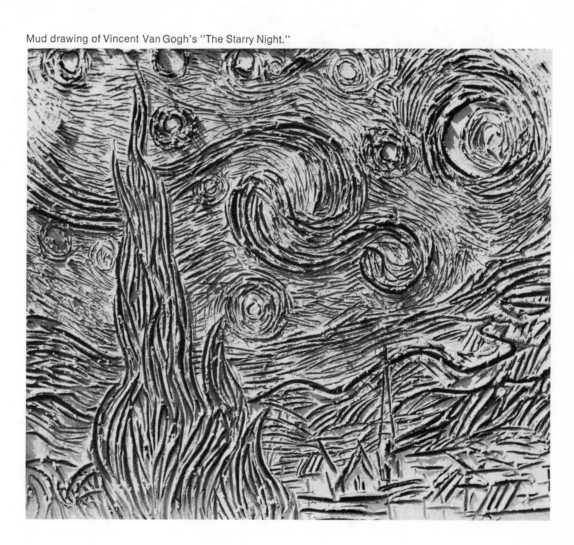

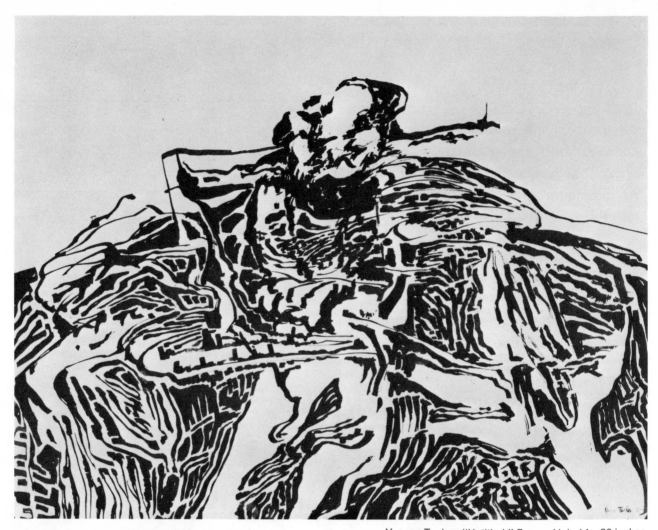

Yvonne Tucker, "Untitled." Pen and ink, 14 x 20 inches.

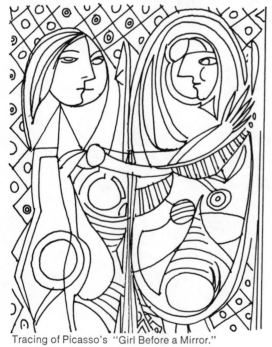

Tracing of Picasso's "Girl Before a Mirror."

Yvonne Tucker has compressed areas of whiteness into patterns as animated as the lines that shape them, while Picasso's "Girl Before a Mirror," which is designed in simply painted yet detailed patterns, loses much of its quality in the linear tracing.

As an exercise, place a piece of tracing paper over the reproduction of "The Starry Night." Using a chisel-pointed pen, follow the

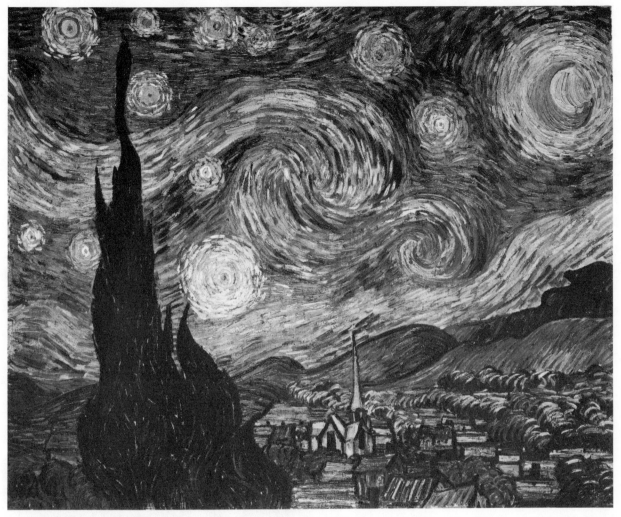

Vincent Van Gogh, "The Starry Night" (1889). Oil on canvas, 29 x 36¼ inches. Collection, The Museum of Modern Art, New York. Acquired through the Lille P. Bliss Bequest.

spiral patterns in the composition. Each stroke should be definite but uninhibited. Accuracy or imitation of the reproduction is unimportant—what matters is the tactile experience of pressure and movement. Compare the finished exercise with the mud version of Botticelli's "Venus." Which of the two seems lyrical? Which seems forceful? Why is the chisel-pointed pen necessary?

A chisel-pointed pen.

The third painting traced in mud was Rembrandt's "Self-Portrait." We find that unless we compress line into areas of tone, the "Self-Portrait" cannot be reduced to line. It is evident that tonality is the key to Rembrandt's work.

Try making your own tracing from Rembrandt's "Self-Portrait." Using tracing paper, follow all visible detail with pen or pencil. Notice how the tonal structure of the painting remains elusive.

The purpose of these experiments is to isolate the visual element upon which these artists depended. It is clear that Botticelli, noted for his colorful patterns, employed a linear design, and Van Gogh used line to create explosive dynamics, while Rembrandt relied almost entirely upon tone.

On the right, Rembrandt van Ryn, "Self-Portrait." Canvas, 33¼ x 26 inches. Andrew Mellon Collection, National Gallery of Art, Washington, D. C. Above, the same painting rendered in mud.

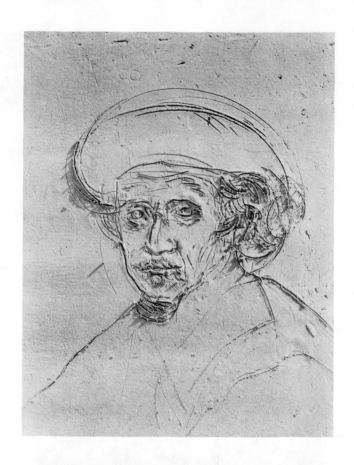

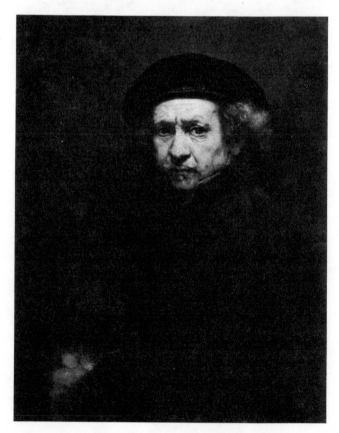

Joy Kinney, "The Agony of Dulcinea." Etching.

William Gropper, "Unfinished Symphony." Lithograph, 20 x 16 inches.

Joy Kinney's "Dulcinea" is a contemporary version of the technique Rembrandt used in his etching. Line is compressed into tonal areas, then extended to indicate the planes and edges, the rhythm of form, and the omnipresence of space.

William Gropper's lithograph is also dependent upon line, which in this case was scraped into the surface of a coated lithographic stone. Obviously the artist's choice of materials and tools affects his use of the visual elements.

3 Tone

Although the importance and value of line alone cannot be denied, when it is combined with tone its full potential can be reached. The graphic, emotional, and psychological eloquence of tone is demonstrated in the intense contrasts of Goya, Daumier, and Siqueiros; in the subtle tone transitions of Rembrandt; in the tonally high-keyed works of Monet.

It is not through coincidence that tone in visual art has the same "name" as tone in music, for graphic and musical tonality are psychologically related. Tonality refers to the range of light and dark in graphic art and to the range of sound in music. In visual art tonality may be graduated into value. In music it is graduated into notes and octaves. Tonal composition in both music and art is com-

posed in keys or positions upon the tonal scale.

But tonality in art also seems to possess nuances beyond analysis. Line, in a poetic sense, is lyrical and descriptive, while tone is infinite and enigmatic.

Black as a color is important to Marie Starr's "Dark Section," as the title indicates. It suggests a section of a large, growing form. Notice how the dark tendrils extend toward the top left of the design. This is a design in which tonality suggests a dark object as well as shadow, or darkness itself.

The emotional qualities of Charles White's work are dependent upon both subtle and strong transitions of tone.

Marie Starr, "Dark Section." Etching and aquatint.

Charles White, "Silent Song." Ink, 43 x 70 inches. Collection Oakland Museum of Art.

Jean Gilland,
untitled pencil drawing.

Arthur Ames, ''Red and Black Lines'' (1966). Acrylic on canvas, 6 x 4 feet.

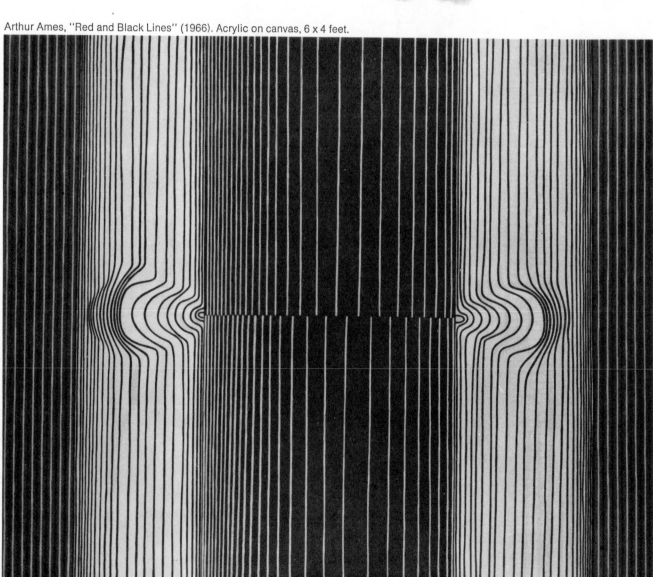

34

In Jean Gilland's vignette drawing the white areas of the paper surround and enter into the main shapes of the design, in which tone structure moves from a middle tone to a dark.

In Arthur Ames's painting the viewer is intrigued by a delicate ratio between line and tone. Are the thin dark lines increasing their width as they extend over the surface, or are the wide bands becoming thinner? Is this also true of the light shapes and bands? Which mass is receding, the dark or the light? It may surprise some to realize that the Rembrandt "Self-Portrait" reproduced in the previous chapter and this painting have much in common. In both paintings, dark and light masses are opposed by thin stripes of the opposite value. In the Rembrandt the dark filaments that surround the eye socket thin out as they extend over lighter areas at the side of the head, while the thin white swirls representing strands of hair gradually fade into surrounding darks.

Both artists, each for a purpose, have used the basic device of combining opposite elements without disrupting the cadence of the design. The values of both paintings are low on the tone scale (see pages 38 and 39). In both, the light areas project from the background. The essential difference between them, aside from abstract or subjective considerations, is that the tonal scheme results in a sharply delineated pattern in the Arthur Ames and in subdued, soft, blurred transitions in the Rembrandt.

In Phyllis Rosenblatt's painting the values extend over the full tonal range from white to black. There is no indication of light, dark, or shadow. Black and white are used as color.

I asked the artist for a few words about her work: "It is the last of a series of seated nudes. The image was on my mind before I painted it. I was especially intrigued by the black figure. It is strong, sensual, and pulsating. There is a regal quality to it and an air of unpredictability and persuasion. The color black strikes me this way."

Phyllis Rosenblatt, "Black Nude." Oil, 37 x 56 inches.

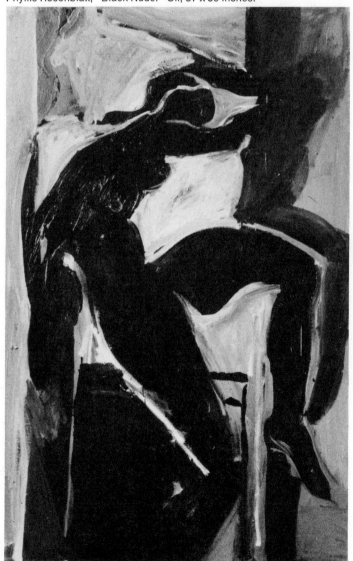

For purposes of discussion it is helpful to divide tonality or value into two separate categories: black and white, and dark and light. For example, the type on this page compared to the white of the paper is an extreme contrast of black and white, while a bright star in a dark sky is an extreme contrast of dark and light. The black letters on the white page play a minority role in the black-and-white scheme, while the bright star in the dark sky plays a minority role in the dark-and-light scheme. Albert Pinkham Ryder (see page 42) translated the natural phenomenon of light and dark into poetic imagery in his ''Moonlit Cove.'' The schematic illustration on page 38, Reference Chart II, will help explain tonality.

Examine the black-and-white version of the color illustration on the next page. Compare each color with its tonal equivalent in the black-and-white photograph. Notice the extreme contrasts in *A* and the narrow, high-key tonal range in *F,* which is the basic color and tone scheme of Claude Monet's ''Ice Floe,'' reproduced on page 40. Also notice the low tonal reading of the red in *A.*

REFERENCE CHART I: FACSIMILE DETAILS

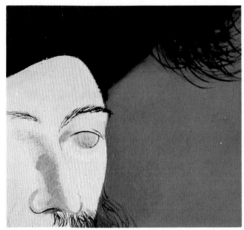

A. Section of "John, Duke of Saxony" by Lucas Cranach.

B. Section of "Windy Day, Auxerre" by Chaim Soutine.

C. Section of "The Birth of Venus" by Botticelli.

D. Section of "The City Rises" by Boccioni.

E. Thickly deposited pigment.

F. Color scheme in a high key, as "Ice Floe" by Claude Monet.

REFERENCE CHART II: TONE VALUES

The figures on the left represent black and white in tonal structure while those on the right represent dark and light.

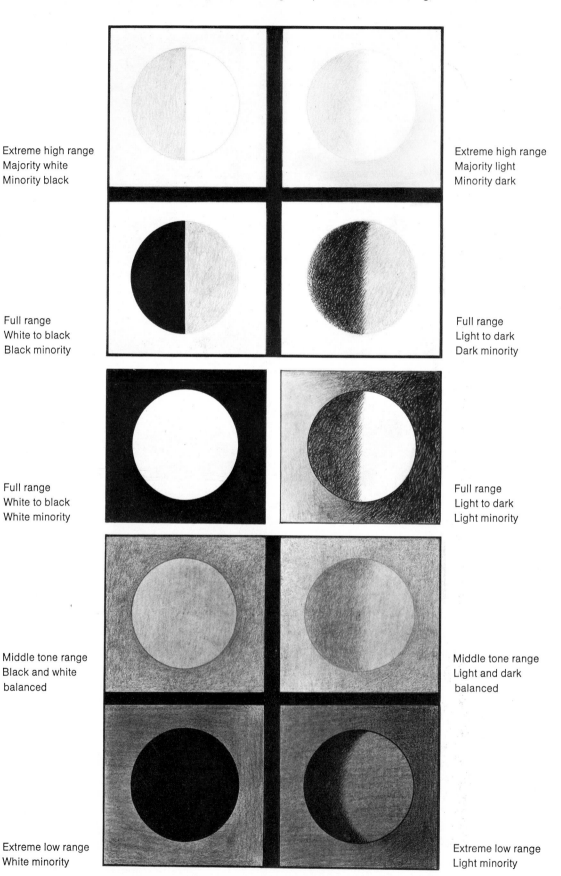

Extreme high range
Majority white
Minority black

Extreme high range
Majority light
Minority dark

Full range
White to black
Black minority

Full range
Light to dark
Dark minority

Full range
White to black
White minority

Full range
Light to dark
Light minority

Middle tone range
Black and white
balanced

Middle tone range
Light and dark
balanced

Extreme low range
White minority

Extreme low range
Light minority

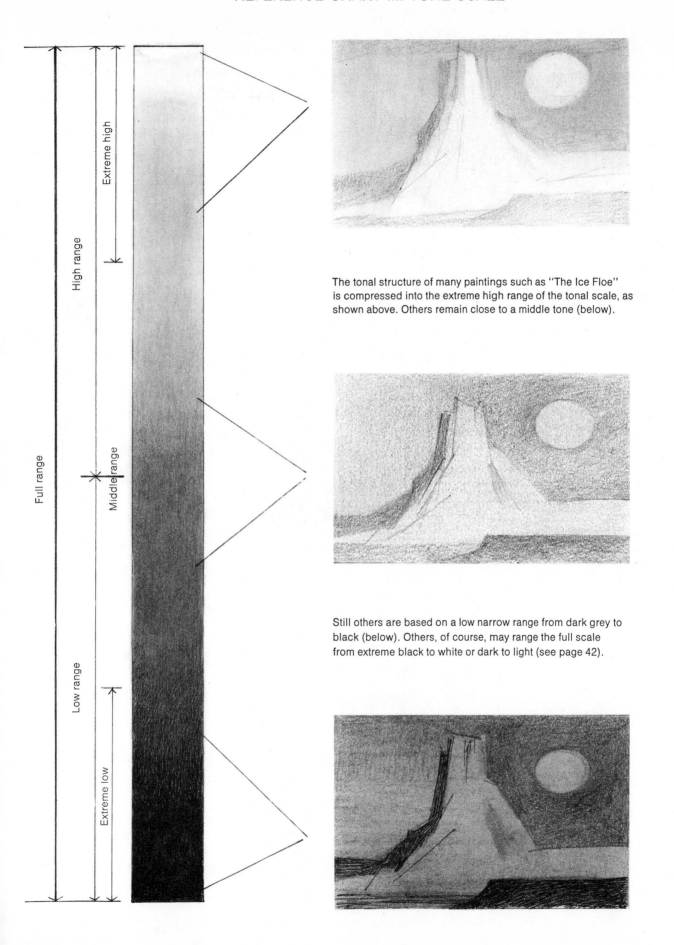

The tonal structure of many paintings such as "The Ice Floe" is compressed into the extreme high range of the tonal scale, as shown above. Others remain close to a middle tone (below).

Still others are based on a low narrow range from dark grey to black (below). Others, of course, may range the full scale from extreme black to white or dark to light (see page 42).

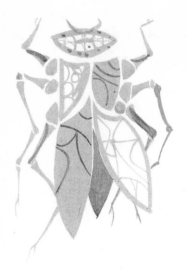

"The Ice Floe," like many of Monet's paintings, was designed in a very high key, ranging from grey pigment to white pigment, conveying a light and dark pattern.

The sketch of the insect is designed in the same tonal range, yet its sharp edges deny atmosphere, light, and shadow. This design is based upon the use of the tonal scale in the black-and-white sense.

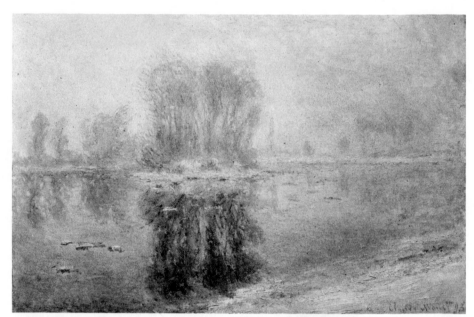

Claude Monet, "The Ice Floe" ("La Débâcle"). Oil on canvas, 26 x 39½ inches. The Metropolitan Museum of Art, Bequest of Mrs. H. O. Havemeyer, 1929. The H. O. Havemeyer Collection.

David Starrett, "Foam on Rocks." Lacquer.

David Starrett's painting, inspired by the brilliant whites of sea foam, also was maintained in a high key.

Toulouse Lautrec's "The Sofa" and Frania Igloe's "Still Life" range close to middle values even though "The Sofa" is impressionistically light and atmospheric while "Still Life" is based upon a black-and-white tone structure in a middle key.

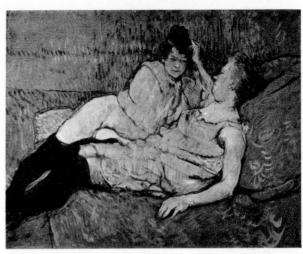

Henri de Toulouse-Lautrec, "The Sofa." Oil on cardboard, 24¾ x 31⅞ inches. The Metropolitan Museum of Art, Rogers Fund, 1951.

Frania Igloe, "Still Life." Acrylic on paper, 18 x 24 inches.

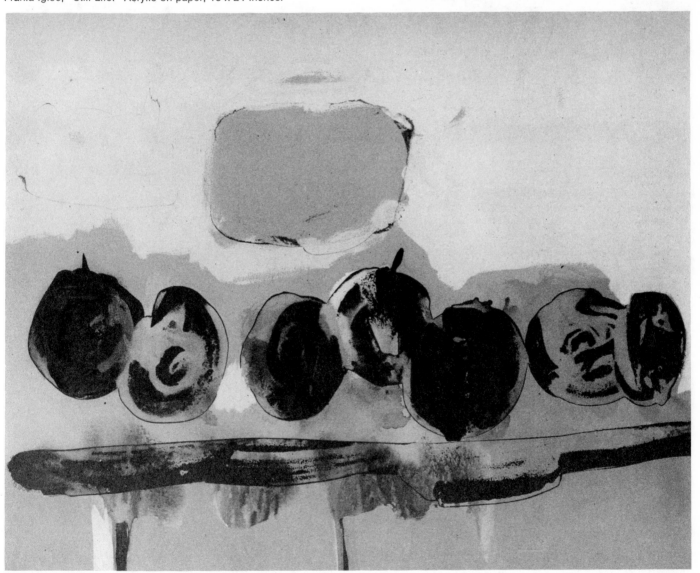

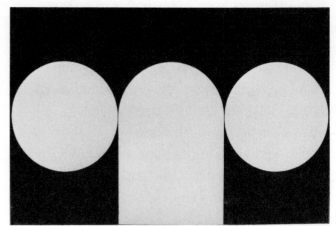

Frederick Hammersley, "That." Oil on canvas, 33 x 51 inches.

Albert Pinkham Ryder, "Moonlit Cove." Oil on canvas, 14 x 17 inches. The Phillips Collection, Washington, D. C.

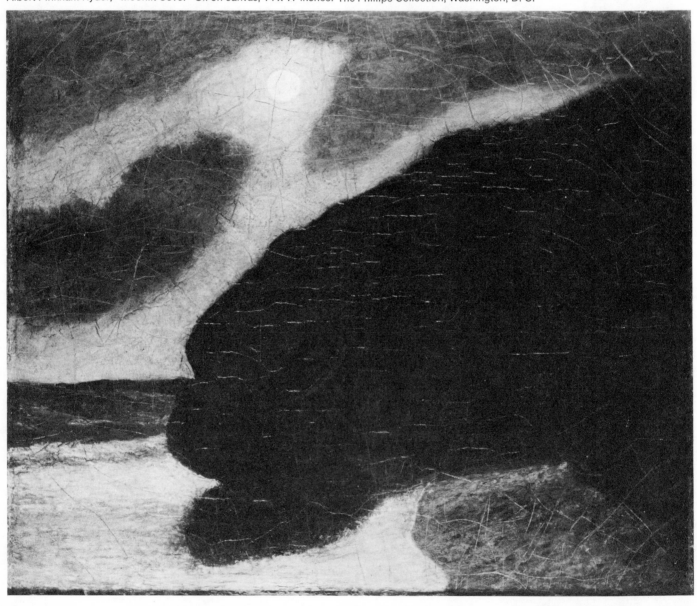

Albert Pinkham Ryder and Frederick Hammersley both employ the full range of values: Ryder in dark and light, and Hammersley in black and white. It is interesting to note that Hammersley uses black and white for their own sake. As we have seen, sharp-edged patterns deny atmospheric tone qualities. See Reference Chart II, page 38, and the diagram on page 45.

No tone value in Wanda Nelson's design rises above the low extremity of the scale. She has merged the values in a continuous tonal pattern, avoiding delineation. Compare this with the painting on page 44.

Wanda R. Nelson, "Woman on the Beach." Oil on canvas, 24 x 30 inches.

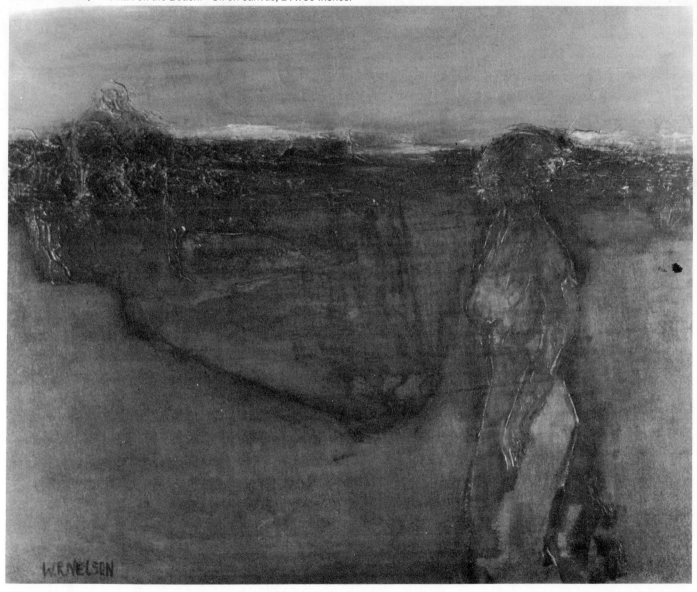

Antonio Rodriguez Luna, "Grupo con Niños." 51½ x 32 inches.

Antonio Rodriguez Luna has exploited the limits of both light and dark, and black and white to convey his sharp satirical intent. Notice the combination of sharp fused edges in a pattern that almost shouts at the viewer.

If the reader compares "Grupo con Niños" with the Rembrandt "Self-Portrait" on page 30, which also extends over the tone scale, he will notice that the Rembrandt finally fuses into the picture plane, while the Luna, fluctuating between strong blacks and whites as well as atmospheric darks and lights, maintains a tension between elements that appear to be on the surface and behind the picture plane.

4 Space and the Picture Plane

In one way or another, all visual art is spatial. Regardless of time or style, the pattern of a painting must extend over a two-dimensional surface, and the success of the design is entirely dependent upon how that surface and area are used.

There is no doubt that any discussion of space must be directly tied to a technical term that is, in many instances, used loosely: the picture plane. The diagram illustrates two extremely different uses of the picture plane. In one case, the brushstroke is flat and is seen as an isolated black shape upon a white area. In the other, the same stroke, slightly blurred and fused into the surface, suggests light and shadow, while white paper suggests deep space and atmosphere. In the previous chapters, we have seen works in which artists bisected, hollowed out, or penetrated the picture plane, transforming a neutral flat area into a personal and eloquent imagery.

I am convinced that the term "picture

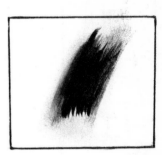

plane" leads to oversimplification of an extremely important factor in the visual arts, and that it can be defined only in relation to individual works or artists. Rembrandt, for example, saw the picture plane as flat area which could be transmuted into majestic spatial depths of tonality and subtle coloration. For Gauguin, the picture plane was a neutral area to be activated by large patterns of color and unconventional symbolic patterns. For Surrealist painters, such as Hieronymus Bosch and De Chirico, the actuality of the picture plane was merely a door to nondimensional regions of the mind. Directly

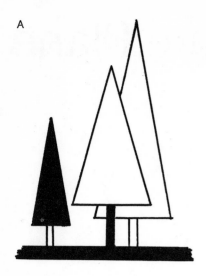

A

B

C

or otherwise, when we discuss a drawing or painting we are, to some extent, referring to a picture plane and the way it was used by the artist. Its psychological ramifications are complex and defy clear analysis; yet we must realize that regardless of how one thinks or works he must eventually contend with a two-dimensional surface, which technically is the picture plane.

Simply stated, we can conceive of the picture plane either as a motion-picture screen upon whose surface an image may be projected or as a glass window upon which we can trace the shape of objects and surrounding spaces beyond it. The picture plane may be imagined as an imaginary two-dimensional surface which intercepts a view of three-dimensional reality. The intercepting surface may be anything from a matchbox cover to the ceiling of the Sistine Chapel. As a simple experiment, stand at arm's length from a pane of glass. Trace with a grease crayon the scene or objects you see through the glass. To accomplish this successfully you must focus your eyes on the objects, not on the glass. When the tracing is completed you may be surprised by the result. You will have traced a view which was intercepted by the glass representing the picture plane.

In the diagram here, *A* represents a real view of a grove of trees; *B* represents the same grove of trees viewed from a different angle; and *C* is a close-up view of a tracing on a piece of glass. Compare the positions of the dark tree.

Many artists emphasize the two-dimensional aspects of the picture plane; others use it to convey the impression of space, depth, or mystery. Frederick Hammersley's ''That''

The concept of the picture plane and design are so closely related that it is impossible to refer to one without implying the other. Consequently this chapter concerns not only the picture plane but the foundations of design as well. The color reproductions on the next two pages show how four different artists use the picture plane.

For Robert Frame the picture plane in his painting is a neutral surface to support passages of texture, color, and tonality. It demonstrates his unusual virtuosity in controlling color and handling paint for its own beauty.

The picture plane in an intaglio print such as Leonard Edmondson's must first be realized on a metal plate, with the artist keeping in mind the very special texture and beauty the paper will give the finished work.

Mischa Kallis intensifies the impression of space and depth by emphasizing the lower-left area of the composition where the streets merge. The color is extraordinarily well coordinated with a strong design that complements its intensity.

Sometimes an artist lets the design within the picture plane develop as it will. Roger Kuntz says of his own painting, "This canvas is one of a number of very *loosely* painted landscapes where the interaction of line, plane, and color form the style of the pictures. I was not striving to impose any style, but paradoxically the paintings of the period arrived at a kind of cluttered hyperactive style all by themselves; the total surface arrived at its own solution."

(page 42) illustrates the former view; Robert Vickrey's "The Labyrinth" (page 54) the latter.

To use yet another metaphor, the picture plane may be compared to a quiet pool of water whose surface can be drastically altered by the slightest touch. Whether it is canvas, paper, or a plaster wall, it should be conceived as an abstract, neutral area whose surface may be activated or violated. The most neutral geometric shape is the circle. Notice in the diagram how the off-center dot competes with the periphery. The most neutral angular shape is a square. Again, notice how even a fly speck must be accounted for within the boundaries of the picture plane. (For a further demonstration of the dynamics of small marks, see Gary Lloyd's "Study for Design" on page 155.)

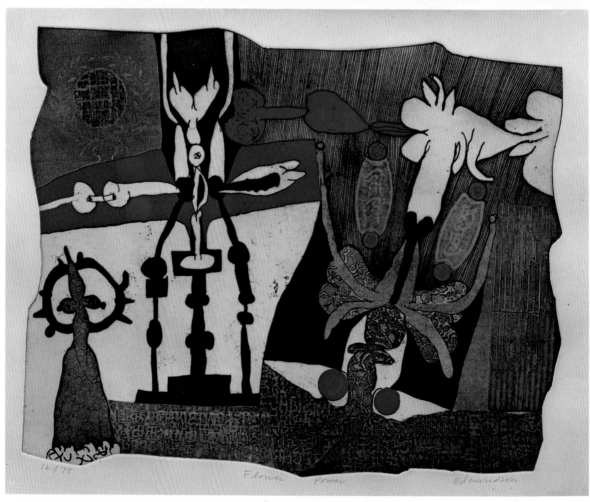

48

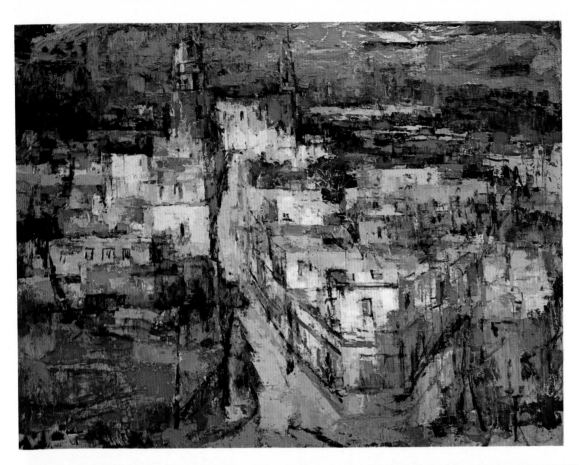

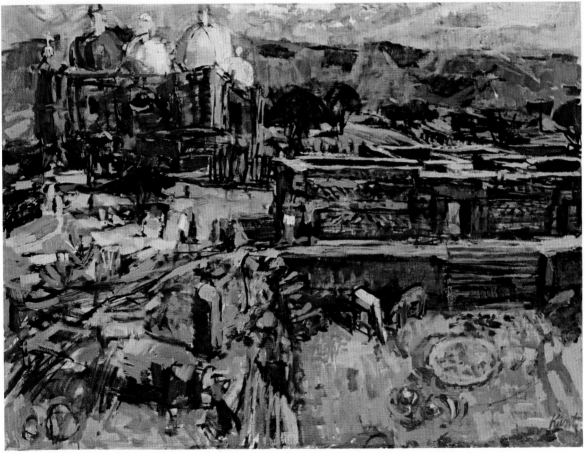

Top left, Robert Frame, "Window on Newport." Oil on canvas. Bottom left, Leonard Edmonson, "Flower Power." Intaglio. Top right, Mischa Kallis, "The Cathedral of San Miguel." Oil on canvas, 36 x 48 inches. Bottom right, Roger Kuntz, "Church at Mitla with Zapotec Temple." Oil on canvas, 36 x 48 inches. Collection of Mr. and Mrs. Giles Kendall.

Tracing of a Cézanne landscape.

The picture plane can also be consciously designed to conform to the personal idiom of the artist. In the tracing of Cézanne's landscape, the interesting feature of the design is the device used to bring the viewer into the painting. Parts of one tree are forced out of the left and top sides of the picture plane, and the existence of another tree outside of the picture plane is implied by introducing its branches within the top right section.

A B

Another example of this device is illustrated here. In *A,* the shape is contained within the picture plane. In *B,* the shape suggests space outside the picture plane.

Mary Dietrich's "Landscape" is a direct painting, completed in one session, in which this painter uses Cézanne's device of surrounding the spectator by introducing shapes extending laterally out of the picture plane.

The image in Harry Sternberg's "Self-Portrait" is cut at the bottom of the canvas, yet the viewer is not forced into the picture, for here we are confronted by a figure, and the viewer, as if in a theater, becomes a spectator instead of a participant.

Mary Dietrich, ''Landscape.'' Oil on canvas, 20 x 30 inches.

Harry Sternberg, ''Self-Portrait.'' 40 x 60 inches.

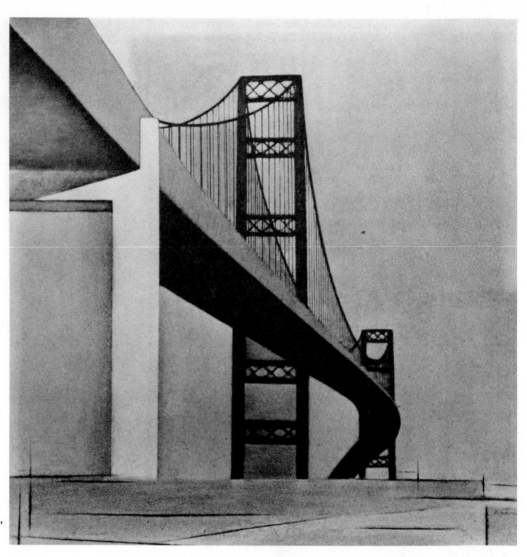

Edward Biberman,
"The Green Bridge."
Oil on canvas.

In Biberman's painting the picture plane is transformed into three-dimensional space. One feels that an about-face would result in a mirror-image view. The abruptly twisting curve representing the bottom of the bridge seems to originate in some distant and unknown region; then, sweeping from behind our point of observation, it continues on over the horizon toward infinity. The result is an impression of space, loneliness, and time.

The design in the sketch explains itself. The ostensible subject may be a bridge, but the true one is time and space, expressed

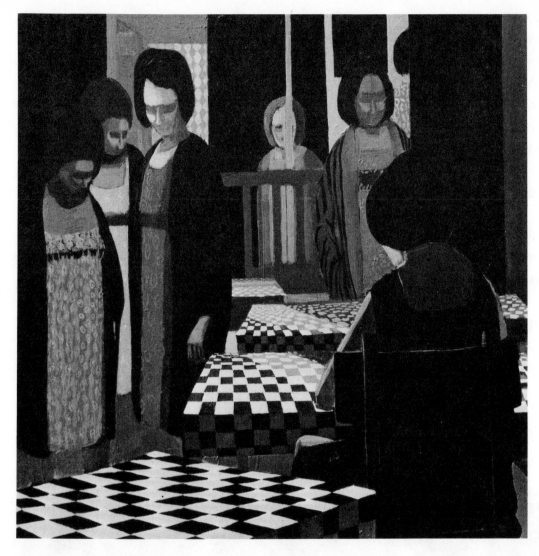

Richard Poole,
"Figures." Acrylic on
Masonite, 24 x 24 inches.

in this case by a sweeping curve plunging
into a horizontal line.

Richard Poole hollows out the picture
plane by narrowing the vertical dark columns
as they approach the middle of the design.
The picture plane is then penetrated
by a series of short, curving thrusts moving
through the static figures to the background.

The diagram translates this illusion into a
hypothetical stage set as it would appear
if viewed from above.

Robert Vickrey conveys a rather somber mood through two basic visual devices. The first is a linear perspective originating outside the picture plane at the left and converging toward a remote region beyond the right and upper borders of the rectangle. He also co-ordinates this movement with a gradually decreasing half-light in the foreground and total darkness in the upper area of the design.

Charlotte Sherman uses the same perspective but distributes the tonal structure of the design in bold, thickly painted, light and dark patterns over most of the picture plane. This results in a visual tension; we seem to penetrate the picture yet are arrested by the textured surface of the canvas.

By controlling dripping paint with movements of hands, arms, and body, Jackson Pollock presented pigment in a new and interesting form. He activated the surface of his canvases with filaments of varied colored tones and textures which seem to swirl perpetually over the surface, recreating in the mind of the beholder the action of the painting process. Gravity, rather than the brush, was the artist's instrument. The picture plane in "Number 1" serves as a foil resisting and supporting descending strands of paint.

Evelyn Carpenter's carefully constructed painting was developed in various stages to achieve an interesting textural surface in combination with a colorful pattern. Like the Pollock, this painting forces the viewer's interest upon the surface of the picture plane. Unless texture is subordinated to tonality or other visual elements, it attracts attention to itself and the surface of the picture plane.

Robert Vickrey, "The Labyrinth." Casein on composition board, 32 x 48 inches. Juliana Force Purchase, 1951, Whitney Museum of American Art, New York.

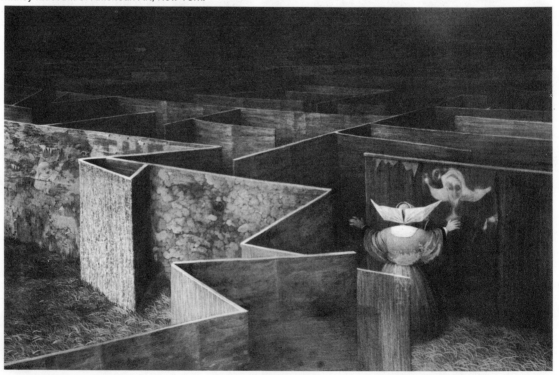

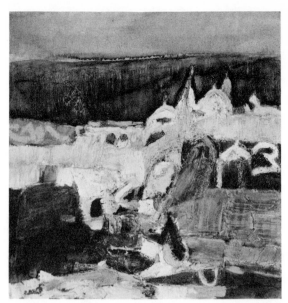

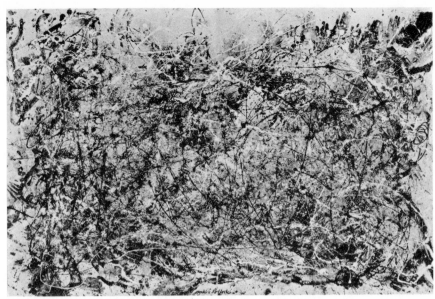

Charlotte Z. Sherman, "Citadel of Golden Path." Oil on canvas.

Jackson Pollock, "Number 1." Oil on canvas, 68 x 104 inches. Collection, The Museum of Modern Art, New York.

Evelyn Carpenter, "Harvest." Oil on Masonite, 48 x 36 inches.

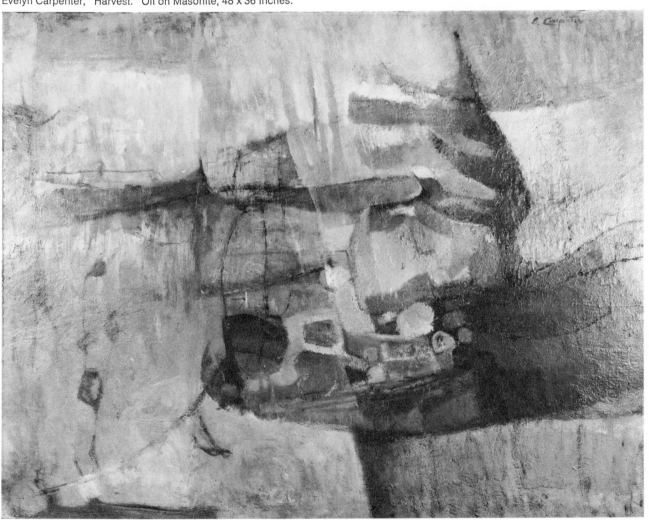

5 Dynamics

Dynamics in the scientific sense deals with the motion of bodies in space. In art, motion may be suggested or implied in many ways by means of all the visual elements, but line seems to be the most provocative and convincing—as we saw from the illustration on page 21. As we have observed previously, spontaneous and emotionally exciting paintings such as those by Soutine and Van Gogh possess a linear character which seems to dominate their design. Like tonality, dynamics can be graduated in intensity from one extreme to the other—from very active to very quiet, from still to swift, from still to slow to swift, or in any other progression. It can only be evaluated within the context of a specific work, such as the woodcut below, whose active pattern is enhanced by the gouging of the wood itself.

In the preceding chapter we saw that the underside of the "Green Bridge" by Edward Biberman is an accelerated linear shape that seems to sweep from the outer confines of the picture plane into the central areas and beyond (see page 52).

Compare it with "Sleeping Gypsy" by Henri Rousseau. The movement or dynamic element in "Sleeping Gypsy" is contained within the painting. The lyrical movement in the drapery of the sleeping figure circulates in an undulating rhythm as if it were an eddy in a quiet pool of water. This motion is also shown diagrammatically.

Ellanor X. Gorny Downey, "The Hunted." Woodcut, 12 x 36 inches.

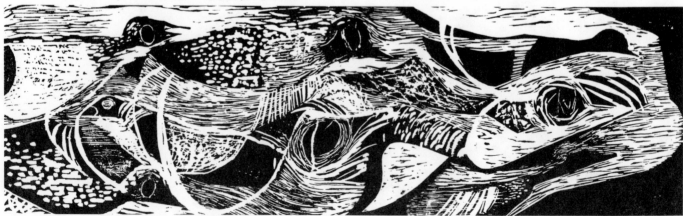

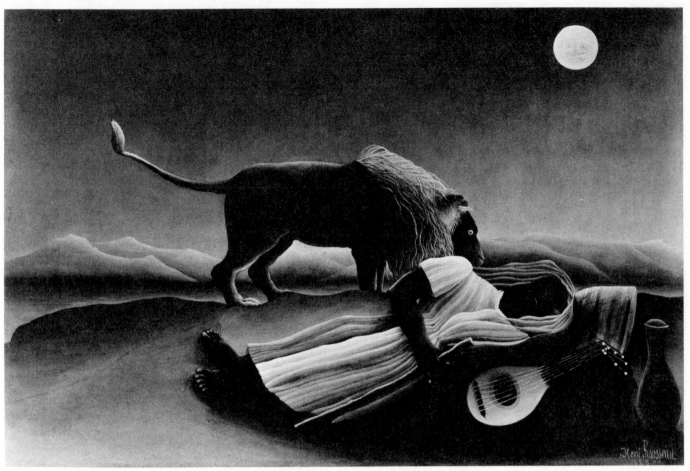

Henri Rousseau, ''The Sleeping Gypsy'' (1897). Oil on canvas, 51 x 79 inches. Collection, The Museum of Modern Art, New York. Gift of Mrs. Simon Guggenheim.

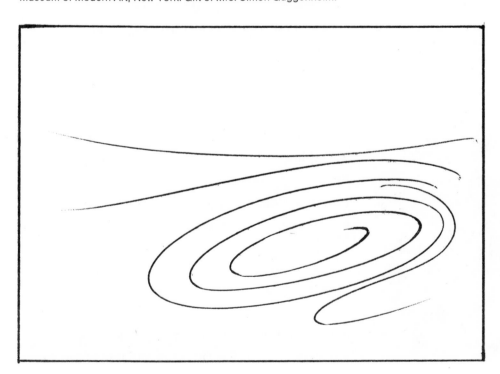

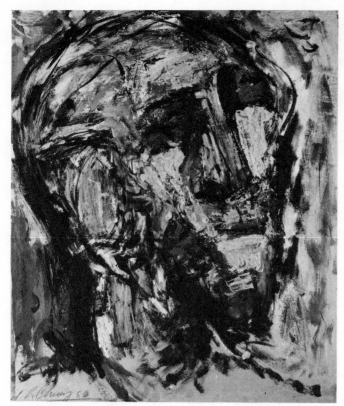

Robert Chuey, "Head." Oil on paper, 40 x 30 inches.

Umberto Boccioni, "The City Rises." Oil on canvas, 6'6½" x 9'10½". Collection, The Museum of Modern Art, New York. Mrs. Simon Guggenheim Fund.

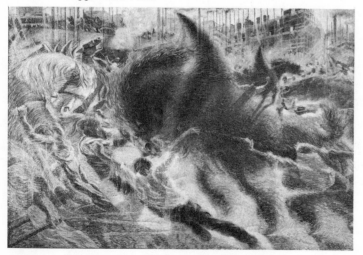

Robert Chuey's loose approach also contains the activity within the rectangle, yet the result is more like a whirlpool; the turbulence extends not only over the total surface but also into its depths. The pigment itself, thickly applied, adds to this impression. See *E* on page 37.

Umberto Boccioni, on the other hand, activates the entire picture plane with a montage of moving patterns, made still more dynamic by the strokes that shape them, so that the viewer is confronted with a scene of motion and activity that seems to extend beyond the confines of the canvas. In this case the picture plane suggests space, motion, and time. (See *D* on page 37.)

Max Bailey's "Sea Bastion" seems almost stationary, but there is movement, contained within a rectangle. The main shape seems to be slowly rising from the bottom of the picture plane, pushing through the horizontal division near the middle toward the upper region. Strangely enough it also suggests immobility, an object that is holding back a massive force that lies beyond.

Paul Keene expresses action and conflict with dynamic shapes superimposed on one another while confined within a rectangle. The effect is exciting, like actual conflict between man and beast, contained in a larger space such as an arena.

Lorser Feitelson's "Blue Line on Red" is an excellent example of a distillation of visual elements to their bare essentials by an artist who has worked in many mediums and styles. Its linearity is obvious, but it is linear

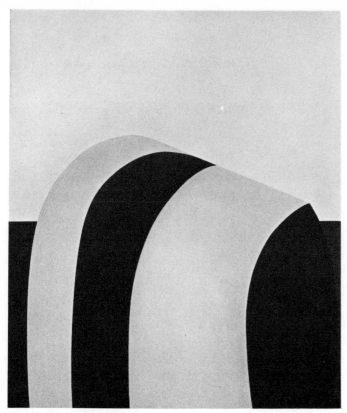

Max Bailey, "Sea Bastion." Oil.

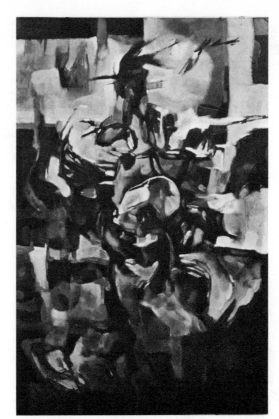

Paul Keene, "Plaza de Toros #16." Acrylic, 40 x 50 inches.

dynamics, not just line itself, that gives this carefully conceived and delicately balanced design its significance. The artist explains: "This painting is enamel on canvas: the line is matte, the background glossy. The 'hard edge' of the line was attained by the use of masking tape. My use, in this painting, of a light-blue line against a large field of intense red creates a surprise reaction in the viewer when he discovers that what at first appears to be a white line has color. He soon realizes that a color line becomes almost imperceptible against a background of intense chroma. I intend these lines to appear dynamic, forcing the eye to glide along the line length; simultaneously, I wish the viewer to experience a contraction and expansion of the space confined within the lines."

Lorser Feitelson, "Blue Line on Red." Enamel on canvas.

David Starrett, "Wave Study." Lacquer on paper, 26 x 40 inches.

"In this study of a wave," David Starrett says, "I started in the studio with a lacquer wash on paper trying to catch the simultaneous feelings of a wave that is about to break and a wave that is broken."

A visual element may be concealed within a design. William Aldrich's "Still Life" has some of the dynamic characteristics of David Starrett's "Wave Study," although they are not so readily apparent. The sharp white shapes below the fruit bowl continue the rhythmic centrifugal movement of the round bowl and fruit.

It is evident that many artists use elements of dynamic design in their work. For some dynamic design is a subconscious act, while for others it is predetermined and carefully worked out. Regardless of how it is achieved, a dynamic pattern automatically stimulates in a viewer a reaction which is rooted in his own experiences with shape, movement, and space.

William Aldrich, "Still Life." Oil on charcoal paper.

Part II. The Act

6 The Artist

The remainder of this book is intended as a practical extension of the theory presented so far. But before discussing how an artist works, it might be best to consider what an artist is and what he tries to do.

The practice of art is not, as many seem to think, the occupation of a gifted few busily involved in the painting of pictures. Just as literature evolved from speech, so the visual arts developed from a human need for an expressive graphic language.

During childhood, when concepts are in a formative stage, the awakening mind is intensely and vividly responsive to the phenomenon of nature and the excitement of sensory impressions. For many it is the only period in life in which they respond to the magic of their environment and participate in the miracle of creation, for a jaded adult society has a tendency to value not the ordinary but only what it considers to be exciting or rare.

By contrast, children and artists force us to re-evaluate objects, events, and conditions which are usually dismissed as being ordinary and commonplace. It is unfortunate that many have allowed the process of physical and social maturation to blunt or totally obliterate the sensitivity and awareness that is normal in the child. The single most important characteristic of the artist is that he has avoided squandering a birthright common to all and has maintained an open line to the mystery and magic of nature.

In this chapter are works selected to relate the natural and fundamental motives of visual expression to the technical and intellectual aspects of art.

Hank Bratt, "Lion." Pen and ink, 6 x 5 inches. An 11-year-old artist.

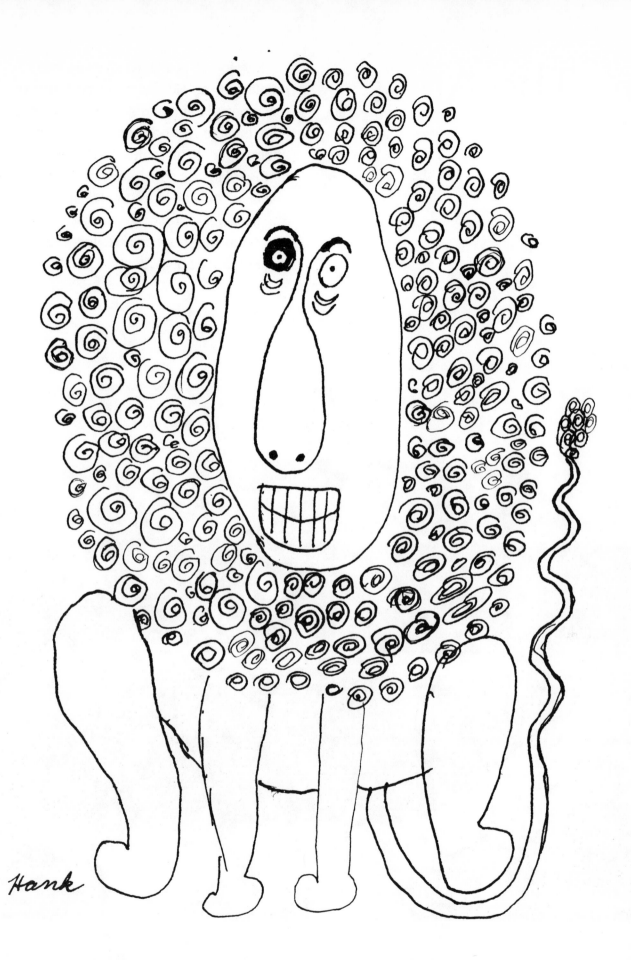

Hank

"My Home" is a first adventure into painting by an elderly man who borrowed a few tubes of paint and a sable brush to record a nostalgic boyhood scene. There is no attempt here to accentuate any particular feature of the design. Each ripple, stone, and leaf is not only an ingredient of stream, wall, and tree, but represents an object or phenomenon experienced in childhood, singled out, and once again identified with the past.

Andrew Tomei, "My Home." Oil on canvas board, 12 x 16 inches.

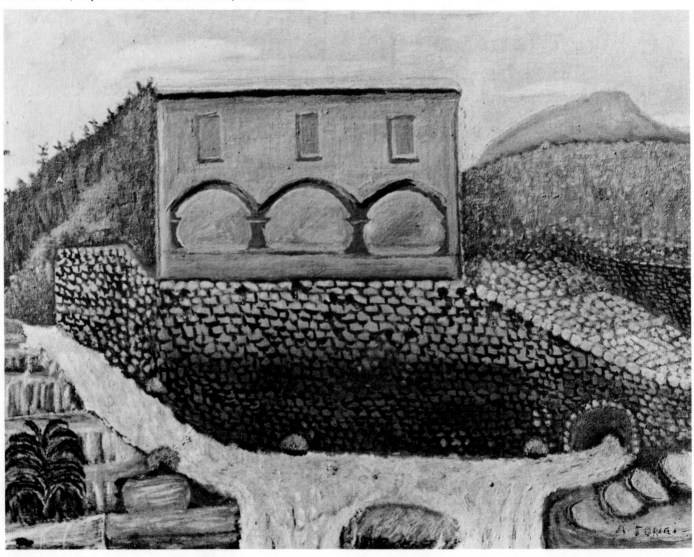

Rocky Candiotta,
"A Day at School." Etching.
A 7-year-old artist.

Bridget Fonda, "Mama & Daddy." Ink. A 3½-year-old artist.

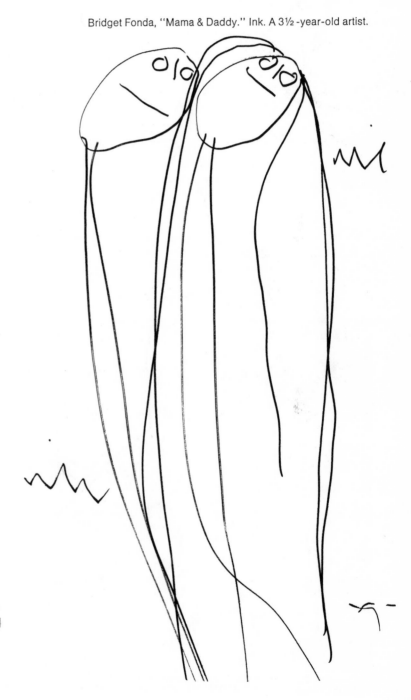

The young etcher uses the *avant-garde* device of placing two designs on one area. He represents a day at school in two scenes, schoolyard and schoolroom. Both views are fragmented into busy patterns describing the activity and denizens of each.

The sketch of her parents is one of a series of "tall people" drawings by three-and-a-half-year-old Bridget Fonda. It is her view of a world inhabited by gargantuan creatures in which her mother and father are not exceptions. This is not the result of a direct observation, but a composite image of her experiences, stated in a positive intuitive act. Notice the bold downward strokes emanating from the all-important head. Partiality was avoided by flanking each figure with its own signature, complete with dotted *i.*

After experiencing a three-day power failure, Romy Cobley was told that her grandmother had fixed the lights. It is logical, of course, to assume that anyone engaged in such a task would require wings. The winged figure in the upper region is the grandmother; the remaining, ineffectual occupants of the house stand earthbound, armless, and helpless below. Needless to say, both Bridget and Romy were commenting on events perceived by the imagination rather than the eye.

For the trained artist a realistic or authentic-appearing representation of a scene, or

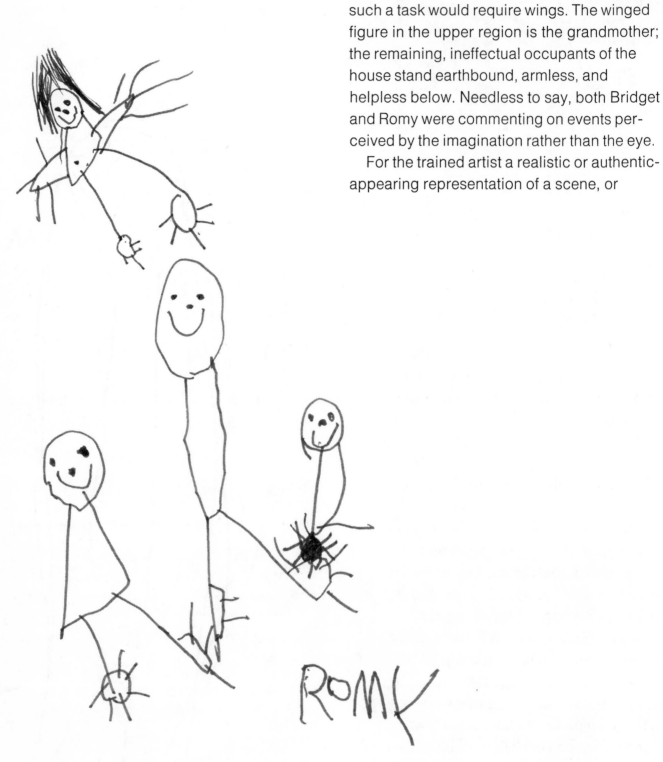

Romy Cobley, "Grandmother Fixing the Lights." Crayon on paper, 9 x 11½ inches. A 4-year-old artist.

object, or even a competent illustration of a literary thought, is relatively simple. Yet, paradoxically, where he is motivated by intangibles of aesthetics and expressive imagery, he immediately experiences an inner struggle between skill and intuition. This is a perennial dilemma in all phases and in all fields of art; every artist must continuously contend with and resolve it.

Following are examples and brief statements by artists who have relinquished the comfortable occupation of ''painting pictures''

for an individual idiom that can be maintained only through constant self-appraisal. The reader will find that regardless of style or medium with one or two exceptions underlying motives and not representational considerations give these works their merit.

Albert Porter gives this explanation of a work's conception: '' 'Knight and Morning Star' evolved out of an exploration of contrasting forms that came together to create this image of man and his destructive weapons.''

Albert Porter, ''Knight and Morning Star.'' Watercolor, 22 x 30 inches.

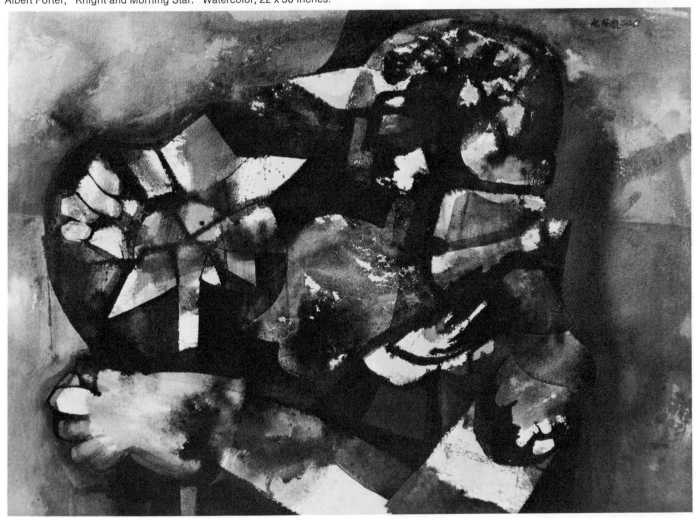

Joseph Mugnaini, "Landscape." Oil glazes over gesso. Collection of Arthur Flanagan.
Keith Finch, "Screenlan Maxfactine." Oil on canvas, 71 x 76 inches.

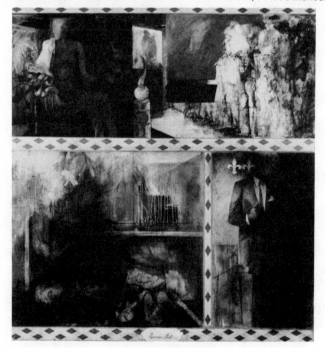

Despite the extreme difference in subject matter, my own "Landscape" and Keith Finch's "Screenlan Maxfactine" have a common motive. Each is somber, contemplative, questioning.

The two paintings opposite reflect past events caused by human action. One could be called a still life with shattered buildings; the other, a landscape with flowers. One is an artifact of violence, the other a casual dropping of a handful of flowers.

68

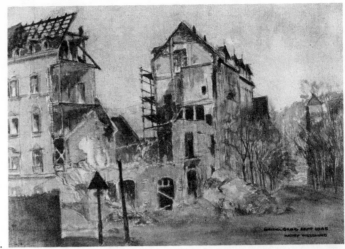

Harry Wesslund, "Heidelberg 1945."
Oil on canvas board, 12 x 6 inches.
Collection of Mr. and Mrs. Joseph Harkiwiez.

Eleanor Blangsted, "Wild Flowers on Blue Chair." Acrylic, 24 x 28 inches.

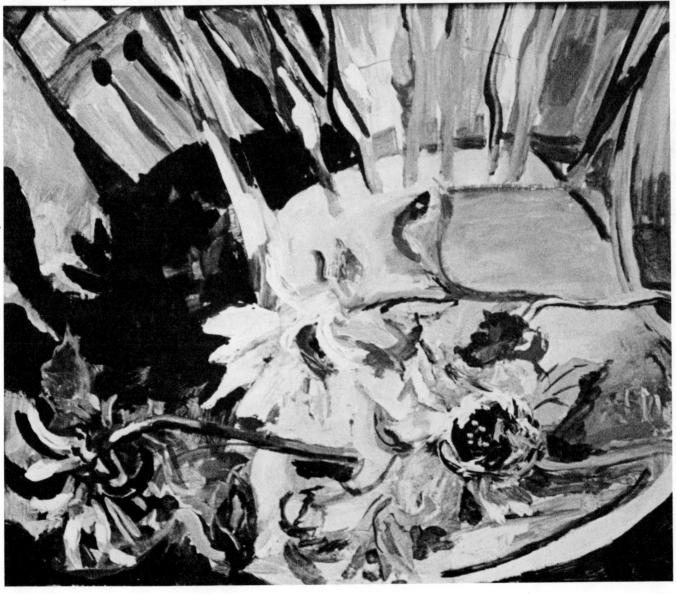

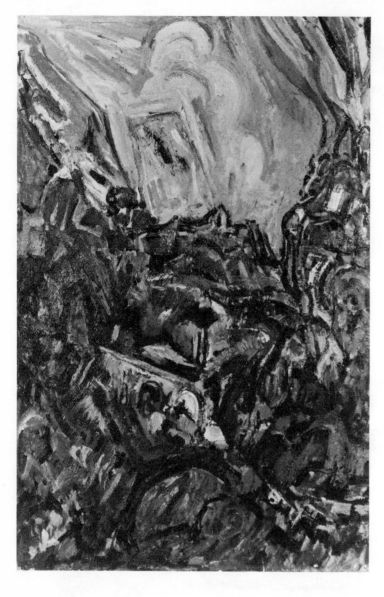

Arnold Schifrin, "View of Marfil" (Mexico). Oil. 32 x 48 inches. Courtesy Fleischer-Anhalt Gallery.

In spite of its title, "View of Marfil" is obviously not a painted replica of a specific area. It is the reflection of an individual's inner vision, which in this case is a contradiction of the usual pastoral scene.

Art does more than survey or describe nature. An exact reproduction of an object or an event is no closer to art than a sound track of natural sound is to music. The merit of the rare painting by Vibert rests entirely upon the artist's amazing craftsmanship and an infallible eye. It is close to being a painted replica of a retinal image. The intent was to duplicate reality. To accomplish this the material must be technically subordinated to such an extent that one is not conscious of its presence. In other words the material (oil paint) must appear to be wood, metal, cloth, etc.

The title of "Desert" is incidental, for the real subject is a semi-abstract variation on a stark theme of nature. In a watercolor, the untouched white areas of the paper serve both as a challenge and as a foil for a calligraphic comment. That comment must be stated with an assurance and sensitivity that can only be achieved with a brush. The freedom of movement and the permanent impression of wetness are outstanding elements of this kind of painting, where pigment is applied transparently. Oil paint applied with turpentine washes approaches this method.

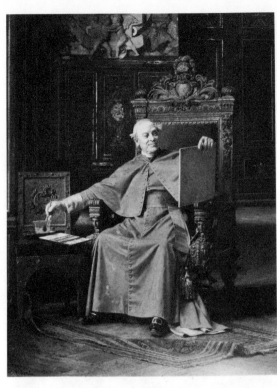

V. G. Vibert, "His Emminence the Amatuer." Collection of Mr. and Mrs. Noah Dietrich.

James Souden, "Desert." Watercolor, 26 x 32 inches.

Bettymae Anderson, ''Untitled #76.'' Intaglio.

Bettymae Anderson's print is designed as a vignette in which the subject and surrounding area combine to produce a sharply delineated contour. The severe contrast between black and white and the delicate equilibrium established between the main shape and the background are the keys to this composition. Here, the intent of the artist is to improvise upon a theme of nature, reorganizing it into semi-abstract biomorphic shapes, while playing a variety of tones in patterns against the surface of the paper.

7 An Approach to Materials

Harold Frank, "Dialogue." Oil on paper, 14 x 28 inches.

First of all we should dispel whatever vestige remains of the stereotyped image of a painter and his materials as a package complete with easel and canvas, tubes of oil paint, and special brushes. As we have observed, canvas is only one of many surfaces a painter may use for his work, while pigment has properties in addition to that of color which may be exploited. An artist's materials should be regarded as a means of expression, not limitations. As Harold Frank says of his painting "Dialogue": "I worked against what I knew. Only when it surprised me did I become interested."

Brushes, the most commonly used and perhaps most widely misunderstood tools of the painter, are considered indispensable by many, but totally useless by some. To understand the brush we should first consider a function more basic than simply spreading paint upon a surface. The brush connects the painter to his surface; it is the link between an artist and his work. However, a brush is not the only possible link. Too many developing artists are stifled by dependence on specific devices and the rituals connected

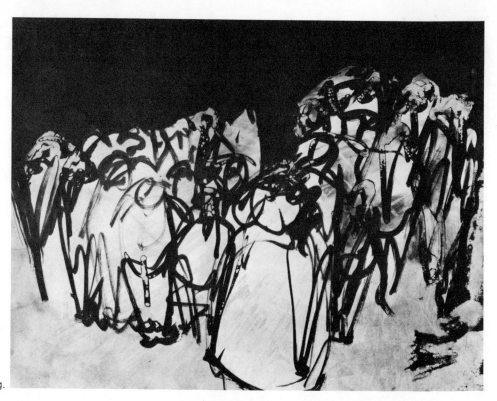

van Benschoten Scranton,
"Group." Brush and ink drawing.

with their use. In saying this I do not wish to deny the value of brushes, but I want to stress that each artist must discover and adapt to his personal idiom whatever device he requires to establish a sensitive contact with his material and his surface.

The quality of the drawing "Group" is dependent upon the virtuosity of the brush. The same subject matter executed in another medium with another device would obviously result in quite a different drawing.

The brushes illustrated are typical of those generally available today. One is round, one flat, and the other somewhere in between. Needless to say, they come in various sizes. The bristles may be pig, sable, badger, or even nylon, among other materials. Although all have unique physical characteristics which should be respected, it is a mistake to place

any of them within a rigid category. Any of them could be used successfully with water-colors, oils, or acrylics. Many painters use watercolor brushes for oils and vice versa. The only rule should be to meet the individual needs of the painter.

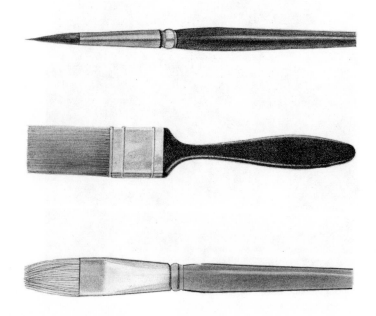

Pigment is the agent through which the subtle and complex quality of color may be realized. Any theoretical discussion of pigment and color without practical application is useless, and thus during the following chapters pigment and color will be directly related to techniques with the recommendation that the reader follow the exercises presented in the text at his convenience. However, the only way to avoid a dogmatic, arbitrary approach to the subject is to try to locate its essence. In this case we must begin by defining pigment and color.

Technically speaking, the different colors are carried on different wavelengths within the wavelength range of the visible spectrum —that is, the range of light. What we see as red is energy moving at the longest visible wavelength (and the least wave frequency). Red-orange is next, then yellow, then blue, and finally violet at the extreme opposite end of the spectrum, with the shortest visible wavelength (and the greatest wave frequency).

Color in pigment is not, of course, like light. Pigments do not emit light, but act on it. Any pigment has to absorb certain wavelengths of light and to reflect others. The reflected wavelengths of light are what we see. (A translucent material, like colored glass, will transmit certain wavelengths as well as reflect them.)

The scrapings of a rusty nail are called, in chemical terminology, iron oxide. It is a pigment. If we mix it with a base or binder of linseed oil, it becomes the oil pigment referred to as Burnt Sienna. If it is mixed with gum arabic, it is called Burnt Sienna Watercolor. If it is blended with a base of egg, it becomes a Burnt Sienna Egg Tempera. The accepted

difference between media is the different bases which bind them; the binder affects the transparency or opacity, texture, drying time, adaptability, and flexibility of the pigment.

Examine the two exercises on pages 76 and 77. The primary colors used in Exercise I are Cadmium Red Medium, Cobalt Blue, and Cadmium Yellow Medium. To do this exercise, place the pigments in the center of the canvas as reservoirs from which portions can be drawn out and arranged as follows:

1. In A, a green area or object, yellow and green are neutralized at the top by the introduction of red.

 B, representing a yellow area or an object such as a lemon, is neutralized at the top by red and blue, making violet, the complement of yellow.

2. A, orange, a combination of yellow and red, is neutralized by blue.

 B, violet, composed of red and blue, is neutralized by yellow.

3. Earth Red, Burnt Sienna, and Yellow Ochre from tubes. Compare with 1B, 2A, and 2B.

4. A, red is neutralized by green.

 B, blue is neutralized by orange.

5. A, pigment mixed equally, resulting in a neutral brown.

 B, color as used in pointillism, in which color is mixed by the eye of the viewer instead of the brush.

This exercise is designed to demonstrate a well-known fact that is lost in the construction of elaborate complementary-color charts. It is that two merging primary colors retain their brilliance, the introduction of a third primary diminishes brilliance, equal proportions of the three primaries destroy it.

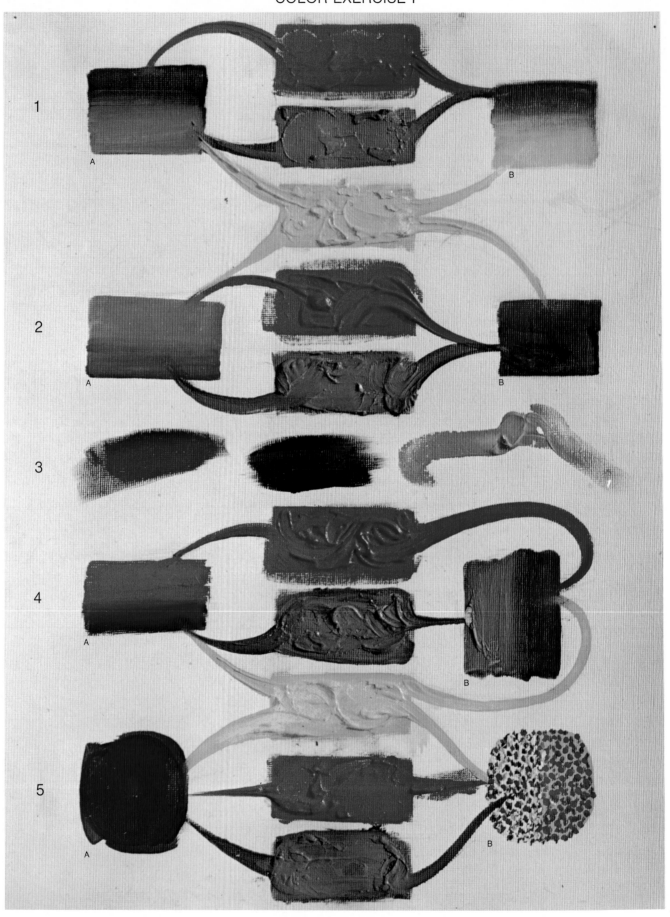

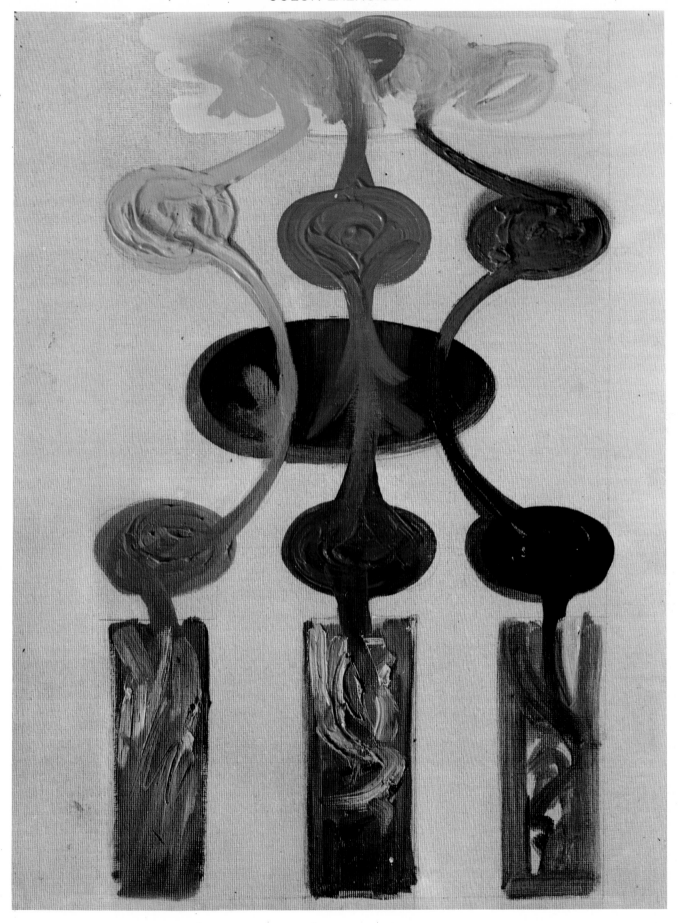

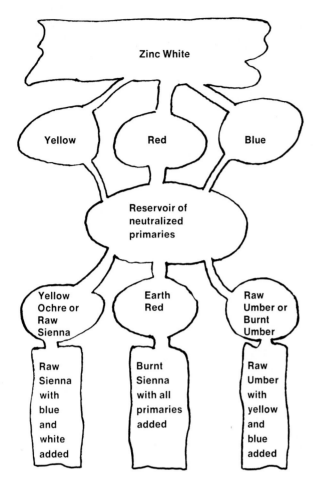

Make your own version of Color Exercise II. Mix the colors as indicated above. First establish a reservoir of umber by thoroughly mixing primaries in the ratio of 2 parts blue, 2 parts red, and 1 part yellow. Place fresh dabs of each primary above the reservoir and with a stiff brush drag each through the reservoir, establishing three modifications of the original umber. Then add to each new base one or more of the original primaries. This latter stage of the exercise may be modified at your discretion. Notice how the handling of the material affects the intensity of the color. Try this exercise with various types of brushes such as those illustrated earlier. This exercise emphasizes the perishable nature of chromatic purity or intensity and how it is affected by manipulation.

In a general discussion of painting, the selection of oils as the most representative medium is inevitable, for no other painting medium has its versatility, malleability, and universality. Thinned with turpentine and used on paper it practically duplicates watercolor. Depending on how it is used, it can match the thickness and texture of encaustic, the opacity of tempera, and the transparency of lacquer. It can also be applied to innumerable surfaces and is convenient to handle. It provides the most logical and practical approach to a survey of basic techniques in all media.

"Marilyn" is a classic example of oils used in a direct manner, applied freely and with great authority. The intent of the artist was to portray a young girl in a candid pose, beginning with a basic pattern of tone over a few suggestions of color patterns previously established in acrylic. He kept adding pigment until he felt that the painting was completed. The total time was less than a half hour.

In relating painting to tonal structure two basic approaches are used. One is to work from dark to light, the other is to work from light to dark. For our purpose the diagrams on page 80 illustrate these methods. They should be kept in mind when contemplating the exercises.

To clarify certain principles I use the terms "advancing form," "retreating form," and "counterform." Advancing form is a mass or plane facing the light source. Retreating form is a mass or plane facing away from the light source. Counterform is space or the half-lighted background.

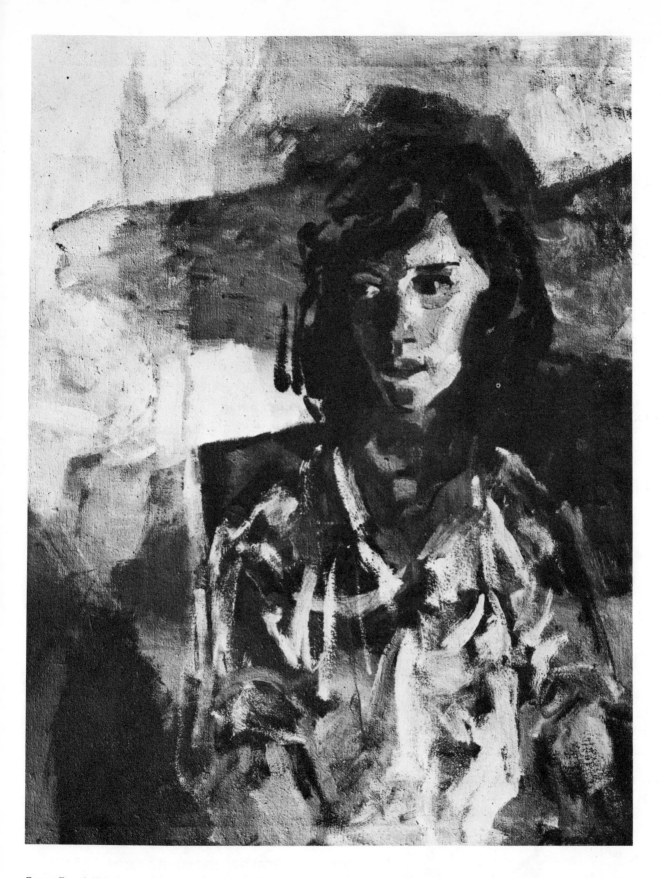

Ernest Freed, "Marilyn." Oil over acrylic, 30 x 36 inches.

Illustration demonstrating the establishment of tone structure starting with a white surface.

The diagrams above illustrate two basic approaches used in establishing the tonal structure of a painting. The first diagram demonstrates the most common approach, working against a white surface. The second demonstrates working against a dark surface.

The top shapes in the first diagram might represent either an abstract shape or a recognizable one, such as an apple, while the shapes below might represent the head and torso of a model. In both cases the artist used

three values to create the illusion of an object in space. The light plane (A), advancing form, is established by reducing the remainder of the area to a middle tone. A dark tone (B), representing the retreating plane, also activated the counter form, or spatial background. Detail (C) is added without destroying the original statement. Both approaches may be used in either a direct or indirect manner, as we shall see in the next chapter.

In the second diagram, a light tone establishes the advancing form and the retreating form and suggests the counterform (A). Next, the lightest area or advancing form is reinforced, the retreating form is also strengthened, and the counterform is modulated to contrast against the darks of the retreating form (B). Finally, detail is added without destroying the simple breakdown of form and space (C).

The system of working against a dark background has been used by Rembrandt and many others throughout the history of painting. It is still used today, especially in techniques that depend upon a tonal underpainting.

Illustration demonstrating the establishment of tone structure starting with a dark surface.

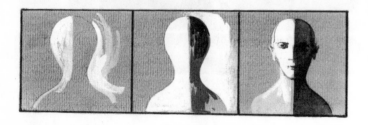

8 Direct Painting

The term "direct painting" is not necessarily self-explanatory. One might think that putting a single coat of paint on a kitchen wall is direct painting, while putting on two coats represents an indirect approach. However, doodling while talking on the telephone is a more exact analogy. Perhaps the most commonly experienced method of direct expression is scribbling with a finger on a dusty table or frosted window. It is the most natural way to work, yet by no means the most simple. Competent direct painting requires the skill and experience to sustain continuous work without hesitancy of execution, unevenness in procedure, or inessential reworking. "Shorty Rogers" is a classic example of direct painting. It was completed in less than an hour, working wet on wet— a method in which the artist works with paint straight from the tube or mixed with either linseed oil or varnish and builds up his pattern while the pigment is still wet. This should be done in one session to maintain an impression of freshness of pattern, image, and technique and to avoid a change of cadence in subsequent applications. There is also the danger that a second effort would end up as a diluted version of a first impression that could never be recaptured, for, as in the Soutine painting (page 13), a consistent momentum must be maintained.

Sergei Bongart, "Shorty Rogers." Oil on canvas. Collection of Mr. and Mrs. Giles Kendall.

Photo by Eddie Jung of subject of Corinne West's "Kathy."

First stage of "Kathy."

The stages of Corinne West's painting provide a photographic demonstration of direct painting. The subject was posed out-of-doors in strong frontal lighting. Color, texture, and an intuitive, almost calligraphic control of pigment were the essential ingredients in this work, while tonality was limited to the values incidental to subject and locale. The work was completed in less than an hour. Pigments were squeezed from their tubes and brushed on without added binders. Turpentine was added only as a vehicle to thin the pigment for a few passages and to wash the brush. Tone and color patterns were

Second stage of "Kathy."

Third stage of "Kathy."

developed simultaneously. This is another example of wet-in-wet painting.

The basic values and color themes are established in the second stage with fluid brushwork that is vertically oriented. The essentials of the design will persist to the work's completion.

In the third stage the vertical movements have been slightly countered by horizontals and angular shapes, staccato in character, which build up texture into a wet base.

The completed "Kathy" is shown in color on page 84. It is a direct painting done in several stages.

"Still Life" is a very skillful painting unmarred by any trace of hesitation or lack of control. It reveals a high regard not only for color and composition but also for the special beauty of paint used boldly. This painting was completed directly, in several stages. The principal difference between this technique and the usual indirect approach, when transparent glazes are used, is that each phase is applied opaquely over an area that has usually dried.

The materials for direct painting are unlimited, ranging from pigments mixed with slow-drying, sun-thickened linseed oil to

Corinne West, "Kathy." Oil on canvas. Collection of Mr. and Mrs. Hugo Mugnaini.

Ann Kendall, "Still Life." Oil on canvas, 36 x 48 inches.

permanently dry pastels. The drying rate of oils depends upon the binder and ranges from slow to fast, beginning at the top of the list:

1. Pure sun-thickened linseed oil;
2. ½ sun-thickened linseed oil and ½ damar varnish;
3. ¼ sun-thickened linseed oil and ¾ damar varnish;
4. Pure linseed oil;
5. ½ pure linseed oil and ½ damar varnish;
6. Straight varnish;
7. Clear lacquer.

The drying rate is dependent upon weather and temperature as well as the thinning medium, which speeds the process.

All binders may be thinned with turpentine or painter's thinner with the exception of lacquer, which is thinned either with lacquer thinner or acetone. Sun-thickened oil is of course the ideal binder for a wet-in-wet painting, as it takes an extremely long time to dry.

Lena Gibbs began ''Landscape'' on black canvas, using a brayer instead of a brush. The paint was rolled on the surface in the large, simple masses which typify this artist's vigorous way of working. The composition was later tied together by strong drawing executed with a brush. The binder was straight damar varnish, which dries much faster than oil.

Oscar Van Young took longer with ''Doubt,'' yet it possesses a spontaneous quality that only a skilled craftsman can preserve. The binder was pure linseed oil. He says: ''At first, I painted large masses of color, ignoring the subject. By means of painting knives and

sable brushes, the image slowly appeared. The lines were superimposed over the nearly finished painting.''

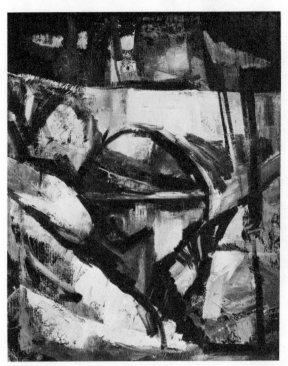

Lena Gibbs, ''Landscape.'' Oil on canvas.

Oscar Van Young, ''Doubt.'' Oil on canvas. Collection of Mr. and Mrs. Harold Foote.

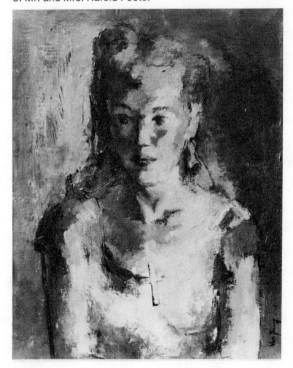

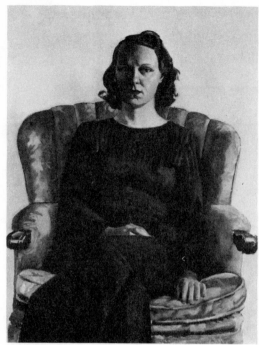

Harry Wesslund, "Wanda." Oil on canvas, 36 x 48 inches.

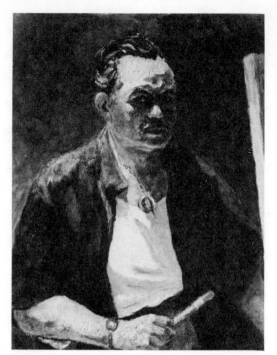

Edward G. Robinson, "Self-Portrait." Oil on canvas.

Barbara Poe, "Pastel."
Collection of Eva Marie Saint and Jeff Hayden.

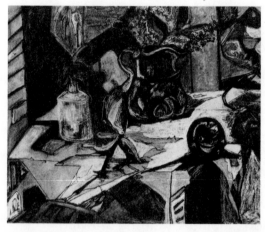

"Wanda" is a direct painting even though several weeks were required for its completion. The fresh appearance results from Wesslund's expert handling of pigment mixed with slow-drying, sun-thickened linseed oil. Compare "Wanda" with Andreas S. Anderson's portrait on page 96.

Both Edward G. Robinson's "Self-Portrait" and Barbara Poe's "Pastel" are direct paintings, although one was done in a wet medium, oil, and the other in a dry medium, pastel.

"Self-Portrait" is distinctive in the freedom of its handling. Notice the heavily applied light areas in the head, shirt, and arm, which were worked against darker areas. Also notice where some of the darker areas are edged into the lighter. (See also *A* and *B* in the color illustration on page 116.)

Barbara Poe uses pastel as one should—lyrically and boldly. It is the driest of the media and for this reason has a unique optical quality. It is regrettable that more qualified artists do not use it. Pastel may be used directly or indirectly; it needs no medium (thinner), friction being analogous to a solvent. It is versatile and malleable, although it may not be used transparently and is not suited for the building of textures.

9 Impasto

The term "impasto" is derived from an Italian word meaning any thick, pasty substance. In painting, it is a method of texturing or modeling a surface over which either opaque or transparent color is applied. The photographs and diagrams here and on the next pages trace the evolution of a class demonstration. It was competed in two phases, with two weeks for the impasto to dry allowed between stages. To do the exercise you will need one or two wide brushes, one or two putty knives, a spatula or wide scraper, lead-and-zinc paste or zinc from the tube, a dark color such as black, blue, or umber, and turpentine. The support should be a sturdy one, such as heavy cardboard or masonite.

The subject, "White Cliffs," was suggested by those present. I began immediately without any preparatory drawing, feeling that the image should be directed by the tool and the

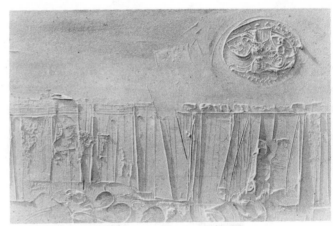

First stage of "White Cliffs." a class demonstration.

material. The first step, above, was to scoop a generous amount of paste from the container and lay in the horizontal and semicircular strokes in the upper half of the design with a putty knife. I followed this immediately with bold vertical strokes representing the dominant facets of the white cliffs. The ridges formed by the sides of the descending blade were allowed to remain as part of the developing texture.

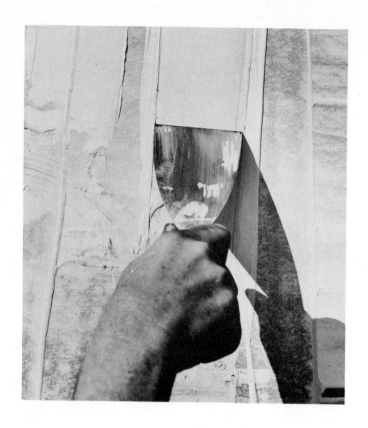

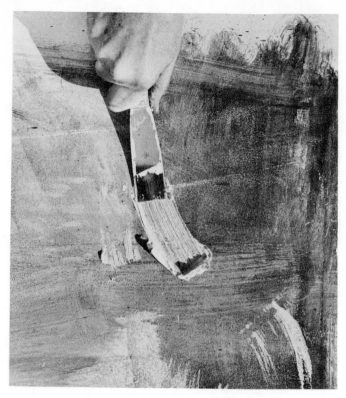

Notice the ridges formed at the edge of the moving blade in the photograph at the far left. Next, texture is modified by using a putty knife with a serrated edge.

At this point, I also dripped zinc and lead paste into the semirounded strokes which suggested a moon. After wiping the blade, I turned it on its edge and scored several vertical and other varied grooves into the previously applied paste. Finally, I scooped up more material and, turning the blade at an angle, allowed it to flow over the blade point in swirling filaments (seen in sections of the cliff and moon) controlled by a skimming motion. The brushlike strokes in the design were produced by using a putty knife which was notched with a small triangular saw file.

Ridges forming at the edge of the blade may be modified by changing the pressure. The corner of the blade can be used to deepen or widen the groove.

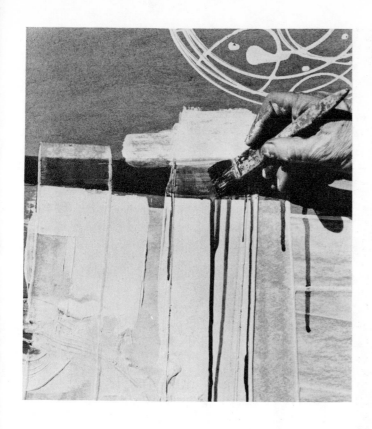

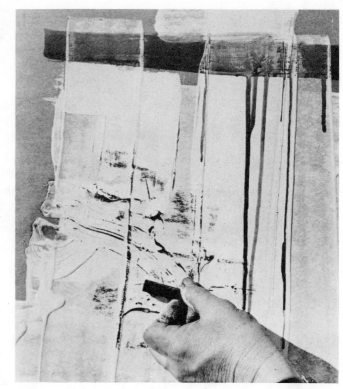

After the two-week drying period, I continued the demonstration by tilting the Upson Board support against the edge of a brick and flooding the upper edge of the textured cliff shapes with extremely thin washes of Ivory Black thinned in turpentine. As soon as the dark wash flowed through the incised channels and surrounded the ridges on the sloping surface, I removed the brick and applied the wash in the moon and in areas of the design that seemed to require tonality.

The illustrations show methods of applying tone or color to a textured surface. Top left, dark wash flows into grooves. Top right, charcoal is rubbed on the ridges. Right, a semidry pigment is applied with a brush. The finished work is reproduced on page 90.

Paste and gesso may be mixed. The variations of texture are innumerable. Crayons, lacquers, inks, charcoal, and oils may be mixed with paste and used with confidence.

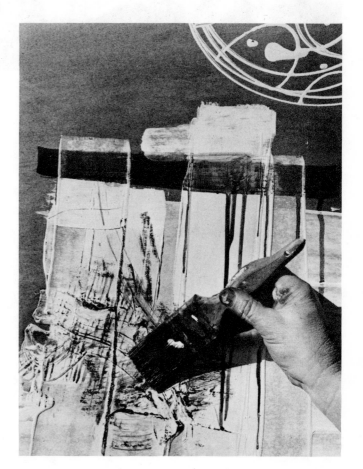

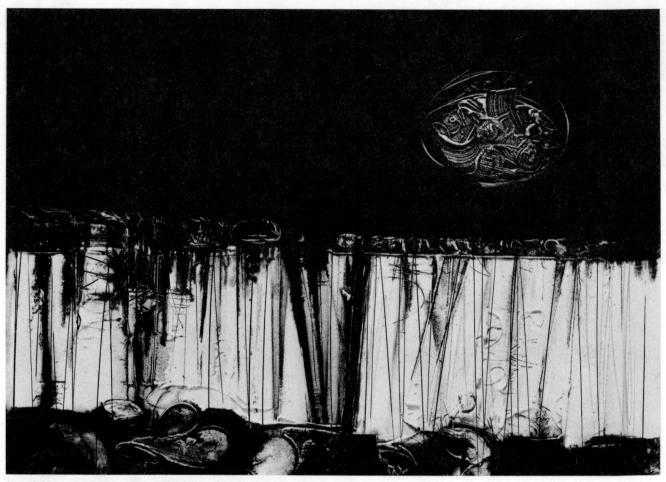

Joseph Mugnaini, "White Cliffs." The finished painting. Collection of Ellanor X. Gorny Downey.

The impasto technique is very flexible. Tom Merola's "Dichotomy" was quickly stated in lead paste, then glazed with oils a month later. Gene Roskiewicz incorporated gesso, sand, ink, and acrylics, as well as decorative materials, in the work seen here in detail. Notice the imbedded objects in the helmet visor.

The detail of a painting by Joseph Gatto is part of a work started with impasto (lead and zinc), completed with charcoal and dyes, then coated with shellac. Perspective and space are indicated in Quentin Robbins's "Sticks" by inserting a few balsa sticks in wet plaster.

Detail of a painting by Gene Roskiewiez.

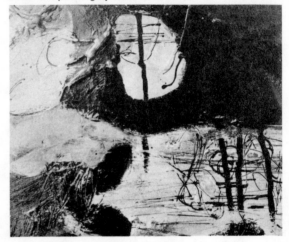

Thomas Merola, "Dichotomy." Oil glazes over white lead.

Detail of a painting by Joseph Gatto.

Quentin Robbins, "Sticks Imbedded in Hydracal."

Gesso and zinc-lead paste are applied in the same manner with the same equipment, yet each possesses distinct properties. The paste is slow-drying and nonabsorbent, while gesso dries rapidly and is semi-absorbent. To illustrate a procedure using gesso which may be duplicated with paste, I had a large mixed-media work, "Baroque," photographed during several stages in its development. Again, I selected Upson Board for the surface, this time a piece 35 x 46 inches. First I sketched a composition in charcoal; then, after filling a plastic container with gesso, I freely dripped and drew the texture pattern shown here. Ordinary plastic squeeze bottles such as those used for tinting hair or for dispensing mustard are excellent for this work.

In the first stage of "Baroque" (top of next page), the impasto design is well advanced. The heart shape has been stained with acrylic, while the thigh region of the rear seated figure has been toned with India ink.

First stage of "Baroque."

In the second stage, the moon has been introduced. Acrylic, ink, and thinned oil washes have been distributed over various areas.

The detail shows how the materials have settled between the raised textures. Some of the ridges will be sandpapered to bring them back to their original white state.

In the color reproduction of "Baroque" on page 94, the texture and color of the Upson Board shows in several areas, including the thigh and chest regions of the front riding figure and the moon symbol. The interplay of materials and textures is of major importance in a work such as this.

"Autumn" (page 94) uses acrylics, gold leaf, and oils. The management of areas, shapes, and color is synchronized with texture. Acrylics, which dry very quickly, were used as part of the underpainting as well as on the surface. Diversity of material is not exclusive to the modern painter. Past artists were deprived of new methods and optional choice of materials by convention and tradition. The contemporary artist is free to choose whatever means and material he requires yet he must still respect principles which are being discussed in this book.

Second stage of "Baroque."
Detail of "Baroque."

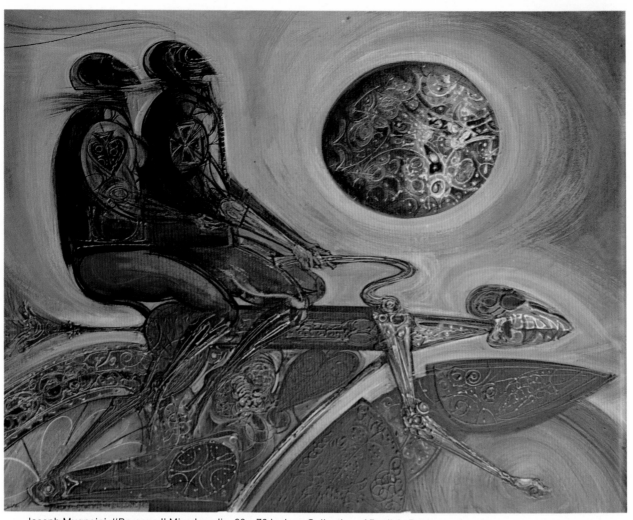

Joseph Mugnaini, "Baroque." Mixed media, 60 x 70 inches. Collection of Basil A. Petricca.
Sueo Serisawa, "Autumn." Mixed media, 30 x 54 inches. Collection of Dr. and Mrs. Omar Fareed.

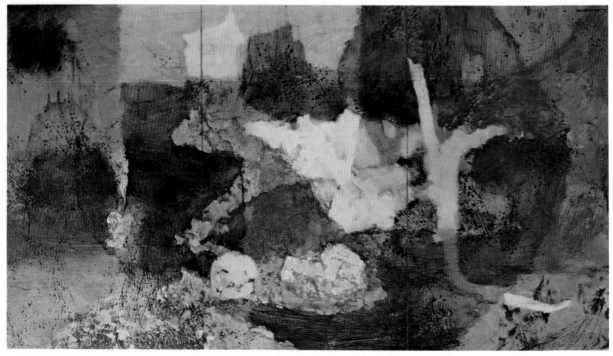

10 Indirect Painting

A clear distinction between direct and indirect painting is neither possible nor necessary. Some simple definitions make a distinction in terms of the procedures and materials commonly associated with each approach. But this can be misleading. Time is *not* one of the distinguishing factors, for both direct and indirect paintings may require long or short periods to complete. Nor does the method of applying material determine whether a painting is direct or indirect—either may be completed in successive stages using one or more layers of paint.

Perhaps we can best illuminate the distinction through an analogy. In the first chapter we compared a direct painter like Soutine to a tightrope performer who establishes a cadence as he starts toward his objective, then sustains his momentum until he reaches his goal. By contrast, an indirect painter is like one who crosses a stream by stepping from stone to stone, each movement a complete stage in itself yet an essential part of the total process.

Top left, Andreas S. Anderson, ''Susan, My Wife.'' Oil on canvas, 24 x 30 inches. Pfeiffer Collection, University of Arizona. Top right, David Schnabel, ''The Betrayal.'' Oil on canvas, 66 x 50 inches. Left, Moselle Townsend, section of a triptych, ''Earth Series.'' Oil collage.

''Susan'' by Andreas S. Anderson was painted indirectly but without underpainting. The artist explains his technique:

''From numerous small sketches, I decided on the general compositional effect. Then, on the canvas, I made a careful charcoal drawing to establish the line, shape, and value relationships. After tracing over the charcoal lines with a light turpentine wash, I wiped off the

charcoal drawing and filled in and built up the color areas, modeling the forms and adjusting the drawing as I went along. Last, using fine watercolor brushes and a hatching technique similar to tempera painting, I completed the modeling and textures in such areas as the face and hair."

Both David Schnabel and Moselle Townsend combine indirect and direct methods. Each work was carefully designed, carried to an advanced state, then completed in a direct manner. In each case light pigment was used in the final stages, thick and relatively dry in "The Betrayal" and in broad fluid strokes in "Earth Series."

The horizontal and vertical bars in "The Betrayal" are directly painted in a high key on a tonal scale. Notice the slight variations in value skillfully contained and maneuvered with a flat-edged brush.

In "Earth Series" the textured shapes forming the peninsula in the lower left of the composition have been trapped, held, and surrounded by the sweeping mass of light pigment. The light pigment also serves as a contrast to the plotted and carefully applied masses in the upper regions. This is a work where some areas were quickly and instinctively stated, and where others had to be meticulously thought and worked out—a combination of both the direct and the indirect technique.

Indirect painting may be studied in the work of Rembrandt, whose technique required that each painting be developed through several distinct phases. Before exploring his approach, it will be useful to learn a little more about pigment and color,

for indirect painting makes use of their subtler qualities.

Color is the most discussed and perhaps least understood of the elements. Remember that it must not be equated with pigment, which is only a medium through which the intangibles of color may be materialized. Pigment should be regarded as an inert substance with potential, which, like a silent string on a violin, can be activated by an artist to express his own idiom. We must think of color in two ways—as an abstract idea and as a specific experience. The idea of red is not the same as the *redness* of a fallen leaf. The redness of a fallen leaf is not the same as the redness of a sunset sky.

A dab of Cadmium Red which might be added to dots of yellow and blue to complete a section of a pointillist work (*C* in the color illustration on page 116) becomes something quite different when it is thinned and spread over a whole section of a canvas, as it might be in a Rubens passage describing the contour of the buttocks of a nude (*E* on page 117). The same dab of Cadmium Red can be extended vigorously over a surface to describe the emotional experience of an Expressionist.

The qualities of color are relative. A segment of a Rembrandt superimposed upon a Monet would seem dark and muddy, while a section of a Monet inserted into a Rembrandt would seem pale and chalky. Thus, color "lives" in its own environment, and color is as much influenced by the proportions in which it is used and the way it is shaped as it is by its environment. Just as a short musical note of any given pitch is different from a longer note of the same pitch, a dab of color is different from a stripe of the same color. A note is shaped by being compressed or

extended in time just as pigment is placed in space (*A, B,* and *E* on page 116).

Color is also affected by texture. A Cadmium Red piece of velvet certainly has a different appearance from a Cadmium Red vase. The diagrams below illustrate how texture influences light and color.

In *A,* light striking an uneven surface is deflected in many directions, revealing a rough texture. In *B,* light reflecting from an even surface reveals smoothness. In *C,* light penetrating several layers reveals transparency.

With these points in mind, let us consider the indirect painting of Rembrandt, using his "Self-Portrait" as an example.

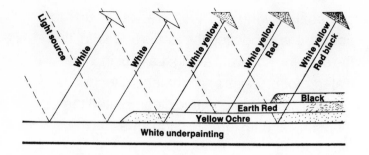

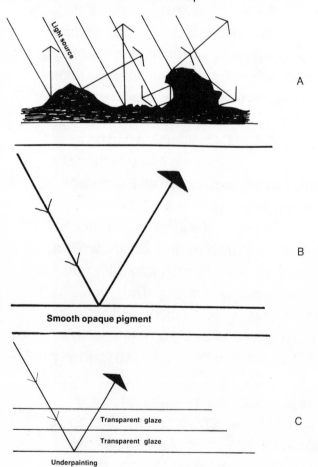

This painting is tonal in structure. It was underpainted, then glazed with a limited palette, utilizing the principle of indirect painting shown in the diagram above. Please turn to page 101 and compare the color to the tone structure. The diagram is a simplified version of light penetrating several layers of transparent pigment, conveying to the viewer a combination of each.

The following exercise is designed to acquaint the reader with a basic method of underpainting; but more important, it is designed to increase his ability to estimate tonality and its relationship to color. By isolating each stage of underpainting the special anatomy of a painting of this type may be compared with other methods which integrate tone and color simultaneously. The technique is based upon several factors: a limited palette; the relationship of pigment to color and color to tone; the isolation of color from tone during the painting process; and the opacity and transparency of the paint.

To duplicate the exercise, the reader needs the following materials and equipment: A surface such as canvas, cardboard, or heavy paper; varnish (damar, copal, mastic, or even spar); turpentine or painter's thinner; casein or any white tempera; oil pigments including Burnt Umber to stain the canvas, Earth Red (Venetian or light red), Yellow Ochre, Ivory

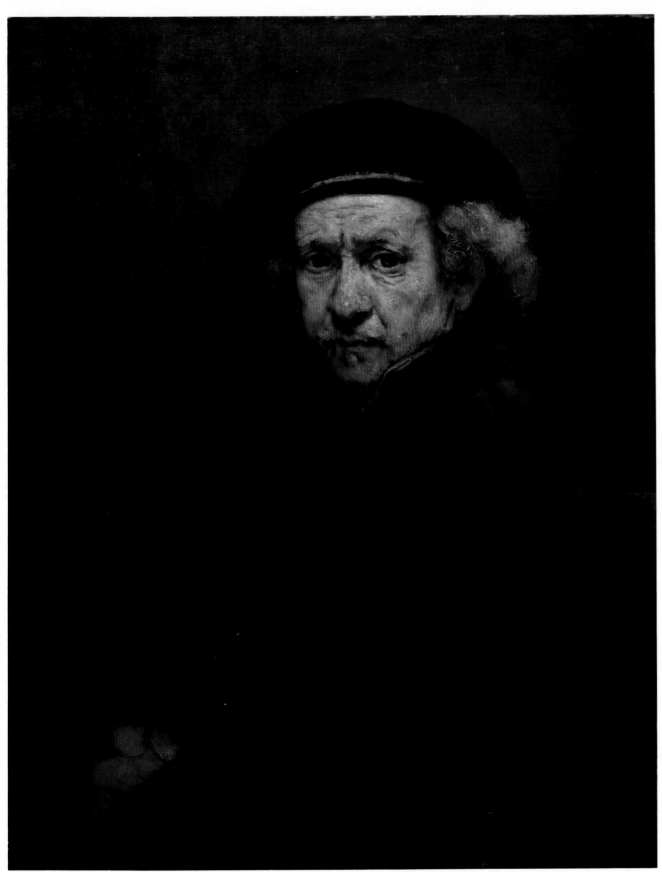

Rembrandt van Ryn, ''Self-Portrait.'' National Gallery of Art, Washington, D. C. Andrew Mellon Collection.

Black, and Zinc White; containers for varnish and thinner; a brush or several brushes, preferably sable or watercolor; and finally, a finger tip.

The reader may copy the Rembrandt or use his own image reflected from a mirror. In the beginning the process is not too different from other methods of painting. The procedure is demonstrated in the color sequence on the next page.

Freely brush a generous amount of thinned-out Burnt Umber on the surface and allow it to settle for a few minutes. The mixture should be thin and stainlike—almost equal to ink in consistency.

Wipe the surface with a soft cloth, using fairly even strokes, until you have reached a middle tone. The surface should have a stained appearance with all excess pigment wiped off.

Make the drawing with a pencil, pen, or charcoal.

Use white tempera to pick out the light areas of the design, as shown in the first two illustrations, being certain to load up the lighter passages.

With thinned varnish as a base, coat the whole surface with a thin glaze of Yellow Ochre, excluding those areas where you think it is not required. Mixture of glaze should be about 1 part turpentine (or painter's thinner) to 2 parts varnish.

At this point the glaze must be allowed to dry overnight, or it might be sprayed with a fast-drying, transparent acrylic lacquer.

Apply thin glazes of Venetian Red where you sense they should be, adding Yellow Ochre or even white if needed. Allow to dry.

Apply a thin coat of varnish over the whole surface and proceed to use the key color, black, thinning it out with brush or finger or increasing the amount where it is necessary. Allow to dry and continue using black in several layers, adding red or yellow wherever they are needed, always maintaining the transparency of each layer.

First we see a detail of the drawing. The canvas has been stained to a middle tone and the underpainting begins. Notice the loose stroking done with a watercolor brush. The lighter areas have been already suggested where casein has been applied more thickly.

In the next illustration, the retreating, darker side of the head has been lightly painted, while the advancing, lighter side has been well established, and the background has begun to surround and contain the main shapes.

In the third illustration, a thin Yellow Ochre glaze has been brushed over the whole surface, then wiped off in the region of the hair where it would interfere with the cool bluish quality intended for this area. A probing, thin layer of Venetian Red has been introduced to the upper-right and lower-left sections to feel out the relationships of all the elements being used.

Next, black has been applied at an increasing quantity in several layers, with drying period between, always maintaining transparency. Notice that white casein has been re-applied to correct the edge of the hat. This can be done while the varnish is still wet but must be avoided when the surface is dry.

The fifth illustration shows integration of the pigments. Notice the full range of color, which is equivalent to a palette set in a

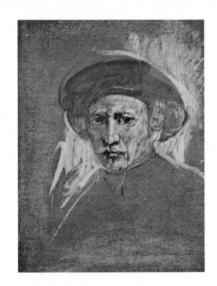
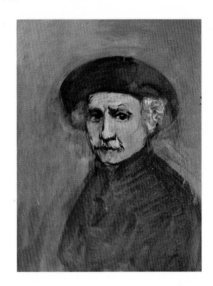
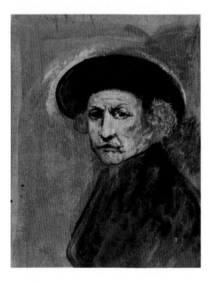
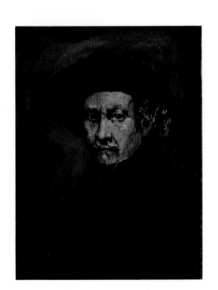

Illustration of six phases of underpainting based on Rembrandt's "Self-Portrait." Executed by John Felter.

low key containing all the reds, blues, and yellows. The violets are a result of merging red and black; the greens, Yellow Ochre and black; the blues, white and black. At this point the selected pigments were applied opaquely in a few light areas, thus intensifying their effectiveness.

After allowing the work to dry the process is carried into the sixth stage, which is essentially the refinement of the previous one

—shown here in detail.

As he proceeds with this exercise, the reader will become aware that he is beginning to think of color not simply as red or green or black, but as intangible states of redness, greenness, or blackness, ranging from the most subtle nuances to extreme intensity. He will also notice that a transparent red is not the same as an opaque red, even though both have the same hue and chromatic value.

Joseph Mugnaini, "The Bride."
Oil glazes over a lead base, 30 x 40 inches.
Collection of Mr. and Mrs. Donald Gilmore.

In my own painting, "The Bride," I used
the same underpainting technique as in the
Rembrandt exercise, except that white lead is
the base and a few touches of Cadmium Red
and Cobalt Blue were added to the
final glazes.

Thomas Harris, "Conversation." Oil on canvas, 24 x 28 inches.
Collection of Mr. and Mrs. A. Daily.

Thomas Harris replaces the fused twilight
darks of Rembrandt with sharply delineated
patterns of tone which parallel the biting
satire of the theme. This is the idiom of Goya,
Daumier, and Orozco, all of whom depended
greatly upon large masses of severely con-
trasting values which have a strong impact on
the viewer. The pigments used were identical
to those used in the previous exercise applied
without an underpainting with a copal varnish
base. The relatively hard-edged patterns in
the design were first painted directly and
refined later in an indirect manner. There is no
mood here, no softness, no atmosphere. The
pattern completely complies with the theme!

11 Working Against White

This chapter may be considered an extension of the previous one, continuing to explore the nature of color and tone. It features an exercise based on a technique, practiced throughout the history of painting, in which color patterns and tonal sequences are gradually developed by interlacing and overlapping strokes of pure color (see *G* in the color illustration on page 116).

My "Landscape," painted as a class demonstration of working against white, was begun with colored inks on heavy watercolor paper. The approach was as to a colored drawing. I began with yellow, progressed with red, and finished with blue and black. Blue was used in thin washes in the sky and dark sides of the mountains.

Joseph Mugnaini, "Landscape." Colored inks on watercolor paper. Collection of Mr. and Mrs. E. Gardetto.

Photo of Red Rock Canyon by Norman Tyre.

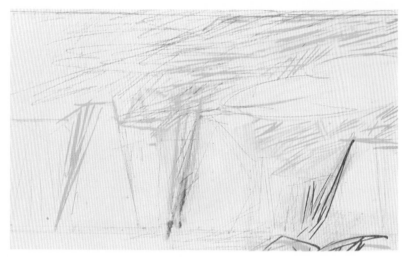

First stage of the author's "Red Rock Canyon."

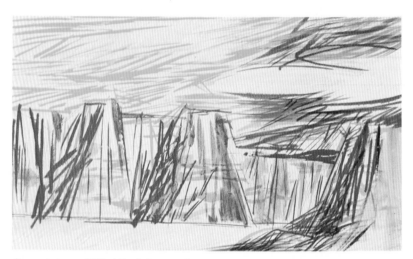

Second stage of "Red Rock Canyon."

Joseph Mugnaini, "Red Rock Canyon." Collection of Mr. and Mrs. Henry Costales.

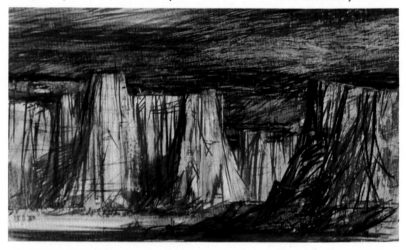

The success of this method of painting depends upon the elimination of white pigment from the palette and, instead, making use of the whiteness of the surface. The surface may be heavy paper of good quality or a white primed canvas. The choice of media is wide, ranging from colored pencils and inks to watercolors and oils. The colors, in contrast to those in the previous exercise, are the primaries, red, blue, and yellow, at their fullest intensity. The secondary colors here are produced by either interlacing or overlapping two primaries, while a grey is produced by introducing the remaining primary. This example is presented as a guide which may be adjusted to individual needs. White pigment, for example, could be introduced as a work reached its final stage. The process also may be used to provide underpainting.

The demonstration "Red Rock Canyon" was completed in one hour, with acrylics as the medium. It may be either copied directly by the reader or used as a reference with another subject. Among other things, it will teach the student to be on guard against a normal tendency to use an excessive amount of white pigment.

Areas of color can be built in stages, as in this method using a water-based medium as an underpainting—in this case acrylics, although any tempera will do.

In the first stage of "Red Rock Canyon," a pencil sketch is followed by thin washes of Cadmium Yellow acrylic applied with a medium-size watercolor brush. In the second stage, Cadmium Red Medium is loosely applied, allowing the basic white and yellow to show through and between each stroke. In the last stage, blue, the third primary, is added in the same manner. As it covers yellow it produces green; merged with red it produces violet; worked into or over red and yellow it produces umber.

In the results, we begin to see that the manipulation and control of pigments must be varied and to understand the mechanics, if not the mystery, of color. The same technique may be tried with other color schemes and media on different surfaces.

In "Red Rock Canyon," I built up the surface in each additional layer to develop a richer patina. This method may also be used as an underpainting over which oils may be applied (see *F* in color illustration on page 116).

12 The Idiom and the Material

Regardless of his method of expression, an artist is one who has established a *oneness* between his intent and his means, and whose technical mastery reflects only thoughts and concepts which are uniquely his own. He has managed to adapt materials and artistic devices to his own being, down to the condition of his nerve reflexes and the state of his glands. In this chapter I have included artists who use materials in individual ways to create their personal idioms.

Of "Oracle II" Lee Chesney says: "The Oracle series, of which this canvas is a part, typifies an approach which has occupied me for several years. Abandoning brushes and the autobiographic implication of the calligraphic gestural stroking previously of great interest to me, I turned to flooding, puddling, and blotting techniques to acquire a less hand-drawn or more *natural* and fluid result— the look of a natural phenomenon rather than a hand-made appearance.

"On this canvas, primed with acrylic latex white and laid flat on the floor, I poured a small amount of turpentine braced with a touch of Lucite #44 over the area to be worked. After distributing this liquid mixture by tilting and squeegeeing, I floated the color

carefully over the turpentine, scraping, soaking, blotting, rubbing, to achieve certain treatments. Variations were possible simply by thinning and redissolving with turpentine the thicker areas and thus reversing the original procedure. If a number of layers are used, a not unattractive, crusty surface results while the very same procedures applied to an unsized canvas will produce a thoroughly stained surface.

"Considerable patience is required to prevent rushing the painting. Maximum control seems to depend on selecting the right moment to make adjustments. A fresh and unlabored appearance depends on deftness, with a minimum of fumbling. As with all such random techniques stringent selectivity is extremely important in preventing the painter from becoming the servant of the happy accident."

Lee Chesney, "Oracle II." Oil on canvas, 60 x 65 inches.

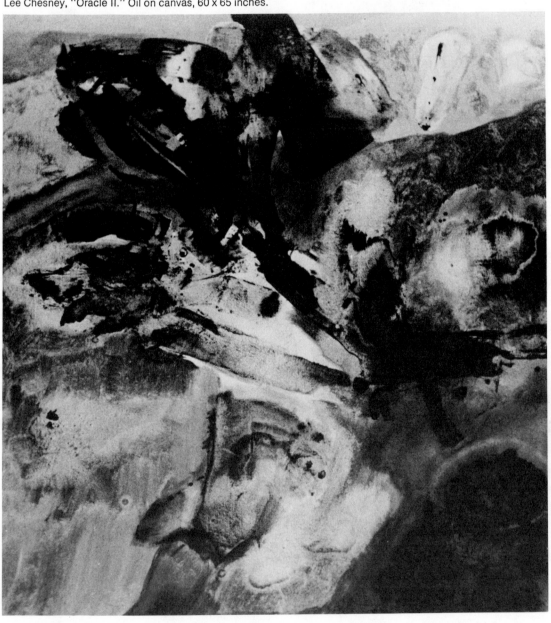

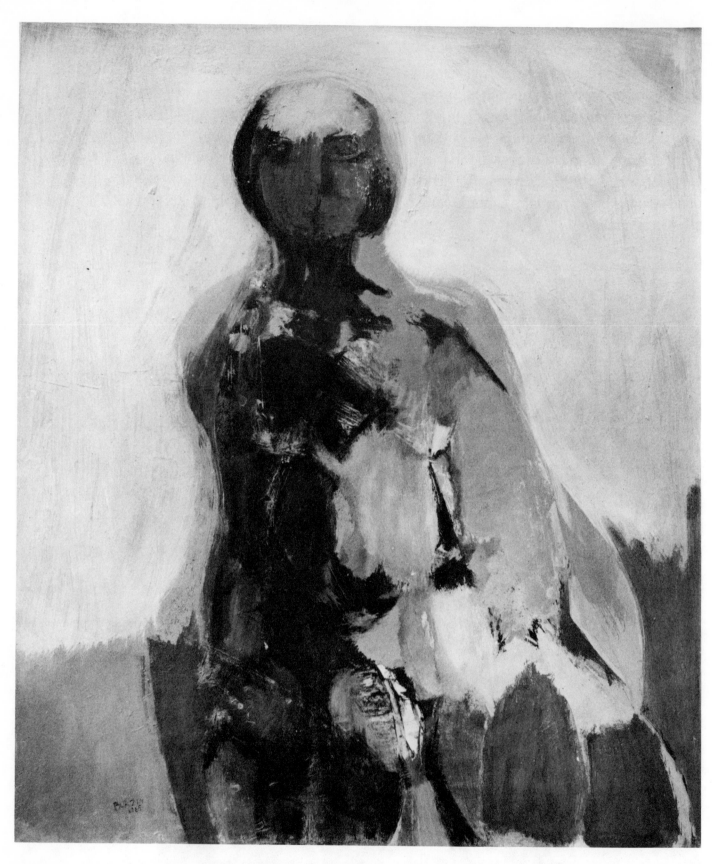

Leon Bukzin, "Figure." Oil on paper, 25½ x 30½ inches. Collection of Dr. and Mrs. Max Igloe.

In Leon Bukzin's painting notice how the light areas surrounding the figure are freely brushed as a counterpoint to the powerfully conceived image, skimming its periphery, invading it briefly, then resuming its original function of opposing and at the same time supporting the principal image. The artist says:

"The painting on paper started as a drawing of two figures and ended as a painting of one figure. For me it is psychologically difficult to start with an expensive, newly stretched, white canvas, freshly squeezed paints, and clean brushes. I am intimidated by that which is new and clean. There is something paralyzing about facing a new canvas. A sheet of paper is less pretentious and one does not take it so seriously.

"With the human figure in mind, I started my drawing. I could see two figures evolving after many starts and much erasing. I then used thinned oil paint and long, soft-bristled brushes. I like the sensual calligraphic stroke of a soft brush. When the two figures started to take shape I changed from turpentine to a mixture of one part linseed oil to three parts turpentine. I worked on this and other paintings during the same period of time. After about a week I hung it on the wall and continued with other things.

"When I started again I felt that greater simplification was needed. One figure was painted out, the color range was simplified, a great deal of the original drawing and painting was changed. After a while I stopped and hung it on the wall. When I started again, it was finished in one day."

Many painters work with very little binding medium, using pigment as it comes from the tube, pressing and scrubbing it into the surface with a stiff brush. There are several ways of beginning a painting using this method. One is first to lay in a drawing, then to block out the color theme in thin values of oil color as a way of organizing the design before beginning the dry technique. Another way is to begin boldly with a direct approach, allowing a substantial drying period between applications of pigment, building textures and color patterns in a gradual, but preconceived, manner.

Some begin by using tempera as an underpainting, while others apply a heavy lead impasto before developing a gradual build-up of color and pattern. This technique, like all the others, must be adjusted to the individual painter's need. There are no rigid rules to follow beyond those of reason and logic.

First, second, third, and fourth stages of Richard Haines's "Saturday's Children."

Richard Haines describes his dry technique: "In developing an idea for a painting I am reluctant to do a detailed sketch or color preliminaries. Rather I will do a number of sketches to clarify the composition that best suits the idea. Then I go directly to the canvas that has been underpainted in some greyed color—blue, green lavender, or earth pink. I either block in the large areas in strong color washes or draw the main objects in charcoal and chalk and begin developing the painting from there. Over the areas of intense color I start weaving lighter opaque paint back and forth across the canvas to develop color relationships and contrast and to define the shapes with which I am concerned. Each square inch of the canvas must contribute to the total image which grows out of the process of painting and my feelings about the subject. In the process I will make many changes, some quite drastic.

"In painting 'Saturday's Children' I had in mind a group of figures in a sparse landscape alongside a wire fence, with no particular event taking place, but with each figure as a kind of symbol that in just being there gives, in some manner, meaning to the whole group. Something like the characters in a play.

"In the first stage shown, I drew in three figures to test out the idea. In the second stage, I had settled on two main figures of the composition and washed in some color, meanwhile trying out various ideas for the background.

"In the third stage I painted in a quite finished group of figures in the middle distance and developed another figure in the foreground. The next day I decided the figure group was too separate to the idea, washed them out, and chalked in a group closer in, with the result shown in the fourth stage.

Fifth and sixth stages of "Saturday's Children."

"In the fifth stage the group of figures became larger and further changes were made in the foreground figures. I spent considerable time developing this group, building up the paint surface and shifting color around with brown clouds in the sky serving as a dramatic backdrop. At this point I decided the group of figures behind received too much attention. I wanted the interest in the painting to be evenly distributed among the various figures. So to produce the sixth stage, I destroyed some of the figures and drew in others, blocking out the landscape. I changed the sky to a Mars Violet, reworking the paint surface and bringing the painting to the kind of finish that satisfied me."

Before going on I suggest that the reader analyze Edward Reep's "The Shrine" and write down a short summation of the methods and materials that the artist used.

Here is the actual process, described by Edward Reep: "This is a toned-ground underpainting (the light cool of the table is the original base color). The canvas was originally glue-sized with rabbit-skin glue, primed

112

Richard Haines, "Saturday's Children." Oil on canvas.

Edward Reep, "The Shrine." Oil on canvas.

with white lead, and tinted the desired color. The cool ground serves not only as solid color in areas but also as the base for numerous glazes to follow. The bricks, in glazed Rose Madder and Alizarin Crimson, for example, depend entirely upon the cool underpainting to show through. In addition, opaque painting simulating the ground color was used in such areas as the steel prison bars to make further use of the ground color which was planned to create a key or color mood. Note the vigorous impasto in the flowers and crucifix which heightens the textural reality. The medium used to glaze and mix: 1/3 linseed oil (pure boiled), 1/3 white damar varnish, 1/3 pure turpentine.''

Preliminary sketches for Edward Reep's ''The Shrine.''

13 The Idiom and the Technique

The true subject matter of a work of art is never a factual representation of an object or an event. To succeed art must deny a generally accepted concept of reality by implying an illusive yet significant truth. Rembrandt's paintings are, for example, symbolic translations of fact which express a philosophy affirming the dignity and mystery of human existence; they should not, for any reason, be considered portraits. He reveals fragments of matter in unfathomable space, sparks of life against a vast inorganic universe, through technical and visual devices especially adapted to his philosophy.

The works illustrated in this chapter were selected as examples of the relationship between recognizable subject matter and the hidden image.

"Geraniums," though directly painted, is imbued with the depth and mystery of a Rembrandt—with a vase of flowers instead of a windmill and a vast unending wall instead of a moody dark sky. The color illustrations on pages 116 and 117 show that painting techniques themselves have psychological implications.

Paul Wonner, "Vase of Geraniums." Oil on canvas, 48 x 48 inches. Collection of Joseph Hirshhorn, Courtesy of Felix Landau Gallery.

A. The red dot and dash were shaped on a prepared red surface by painting white around them. The human eye can detect these subtle nuances and therefore they must be considered as part of the design.

B. The red dot and dash were painted on a white surface.

C. Juxtaposition of color.

D. Texture was developed by scraping with the end of a brush in a wet surface and loosely dripping wet pigment in other areas.

E. Pigment (red stripe) is influenced by changing environment from left to right or vice versa.

F. Oil glaze over acrylic.

G. Cross-hatching method of building color.

H. Direct use of thick pigments: Yellow Ochre, black, Venetian Red, and white. Notice the range of color quality which can be achieved with a limited palette.

I. Dry and wet application of pigment flanked by a pigment white and a surface white.

A

B

C

D

E

F

G

H

I

A

B

A. Pigment applied on a dry surface.

B. Pigment applied on a wet surface.

C. Pigment dripped, then scraped with the end of a brush near the center of the diagram.

D. Extremely wet pigment thinned with turpentine in the center of the diagram and mixed with turpentine and water near the edge of the diagram.

E. and F. Two ways of moving one area of pigment into another: one by continuous brushing or rubbing, the other by a free staccato application.

C

D

E

F

117

Hans Burkhardt, "The Warning Against Smoking." Oil over thick vinyl, 4 x 5 feet.

Frank Sardisco, "Blue Birth."
Acrylic and oil on canvas, 50 x 60 inches.

In "The Warning," "Blue Birth," and "Night Herd," each of the artists has used a heavily textured surface to convey common themes. Hans Burkhardt presents a harsh image of death, with a loose, vigorous style. Frank Sardisco celebrates the renewal of life with carefully worked layers of colored glazes over a spontaneously stated underpainting. Margaret Hehman strikes into a pretextured canvas to shape a symbolic gathering against darkness and a common enemy.

Margaret Hehman, "Night Herd." Oil on canvas, 24 x 36 inches.

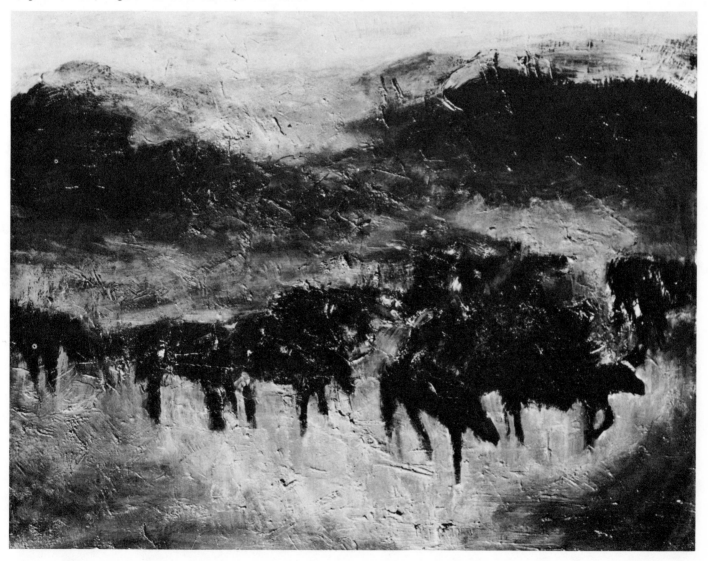

Actors are the subjects of many amateur and professional artists. Here are a few sketches and paintings, covering a period of several years, of the well known actor Sam Jaffe. John Huston's casually done pencil sketch was made when the actor was beginning his career.

A seven-year-old girl sketched Jaffe while watching a TV show in which he appeared.

Nancy Anderson, "Sam Jaffe." Ball-point pen. A 7-year-old artist.

John Huston, "Sam Jaffe." Pencil drawing.

Abe Birnbaum sketched the actor during a period when he was playing as King Lear.

While Jaffe was a guest in George Gershwin's home, the composer sketched him from life with an ordinary pen.

Bettye Ackerman, who is Jaffe's wife, did her etching from memory.

George Gershwin, ''Head of Sam Jaffe.'' Pen and ink drawing.

Abe Birnbaum, ''Sam Jaffe as King Lear.'' Brush and ink.

Zero Mostel's quickly conceived and freely painted image of Jaffe is an excellent example of Expressionism by a master draftsman. This is the portrait of a man yet it is also an image of the artist's emotional reaction to the subject. The medium (oils) was used directly with a small amount of linseed oil. Compare this with Soutine.

George DeGroat says: " 'Arborae' is a direct painting started with only a general idea of a landscape in mind. The initial gestures of pigment set up a situation involving shapes, color, spatial relationships,

Zero Mostel, "Portrait of Sam Jaffe." Oil on canvas.

George DeGroat, "Arborae." Oil on canvas, 24 x 36 inches.

Harrison T. Groutage, "Colorado Winter." Acrylic, 20 x 26 inches. Ranch Kimball collection, Salt Lake City, Utah.

and other elements essential to the structure. Thin washes were applied until the image of a landscape emerged along with the design. At this point increasingly heavier impasto strokes of pigment were used."

A listing of the objects represented in "Colorado Winter" and "Riders in a Landscape" would be identical—trees, sky, grass, earth, and water—yet the impressions conveyed by the two works are quite different.

"Colorado Winter" is a broadly stated tonal painting. Notice the sharp-edged masses in the upper region of the design and how they advance the impression of light reflecting in the distance. This implies space, and the mystery of nature. "Riders" is a briskly painted work, yet essentially indirect in its

development. Unlike "Colorado Winter" the light permeates the total area and is sensitively diffused throughout the leaf masses of the trees. A romantic, lyrical mood seems present.

Jean Jourdain, "Riders in a Landscape." Oil on canvas, 24 x 30 inches.

Perhaps the rocks in my painting infuriate the sea with their inflexible stubbornness, but there are periods of armistice and calm. Both of these states are represented through one subject, which symbolized for me the timeless conflict of universal forces. The painting as a seascape is incidental. This may be considered a color reproduction, for it has a black-and-white color theme, developed by glazing Ivory Black and damar varnish over a white gesso impasto.

George DeGroat used the same subject to express almost the opposite thought, as he explains: " 'Sea and Rocks' was primarily designed to indicate the unity of sea, sky, and earth.

"As in painting figures, still life, or landscapes, there was no attempt here to make a portrait of a particular rock. Instead my efforts were directed toward the idea of *all* rocks as they are washed by the sea and merge with it to become an integrated whole."

Joseph Mugnaini, "The Rock."
Oil over gesso impasto, 24 x 28 inches.
Collection of Mr. and Mrs. A. Daily.

George DeGroat, "Sea and Rocks."
Oil on canvas, 24 x 36 inches.

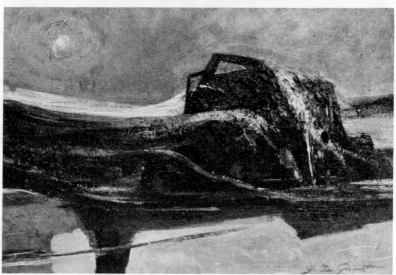

Millard Sheets, "Point Arena."
Watercolor. Courtesy Dalzell Hatfield Galleries.

Milford Zornes, "Point Arena."
Oil on canvas.

Millard Sheets and Milford Zornes worked at the same location, Point Arena, but one could hardly say that their *subjects* are the same. The watercolor by Millard Sheets produces a sensation of light, color, and space. It is a lyrical celebration of nature. Milford Zornes explains the reasoning behind his very different painting: "On returning from a trip I learned that England had entered World War II. Feeling depressed, I sketched out this design and finished it later in my studio. As I worked, the dark, onrushing sea became symbolic of an invading army, while the large, angular rocks in the foreground represented to me a sturdy symbol of resistance." Even though the locality was the same for both artists there is no doubt that in each case the subject matter originated from within and the observed object served as a catalyst to symbolic statements.

Gustav Klimt, Ben Shahn, Mark Tobey, and Jean Dubuffet have used similar devices in the compositions shown here. In spite of obvious similarities, however, the subject matter of each work is unique. The element common to all four paintings is the elaborately detailed, enlarged mass serving strangely to emphasize, by contrast, a smaller, less detailed shape or figure.

The large, detailed mass in Klimt's "The Park" makes the viewer feel as small as the diminished figure in the lower left. The oblique downward view and the inert figure in Shahn's "Pacific Landscape" imply a bleak image of death and timeless space.

Gustav Klimt, "The Park." Oil on canvas, 43⅜ x 43½ inches. Collection, The Museum of Modern Art, New York. Gertrud A. Mellon Fund.

Ben Shahn, "Pacific Landscape." Tempera on paper over composition board, 25¼ x 39 inches. Collection, The Museum of Modern Art, New York. Gift of Philip L. Goodwin.

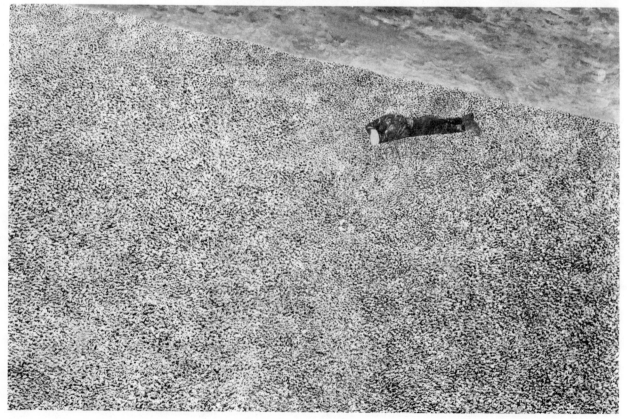

The biting comment made in Dubuffet's leering Humpty-Dumpty, cactus-textured image belongs to the satirical tradition of Jonathan Swift, Lewis Carroll, and Voltaire. This is a graphic replica of one of Dubuffet's mental barbs.

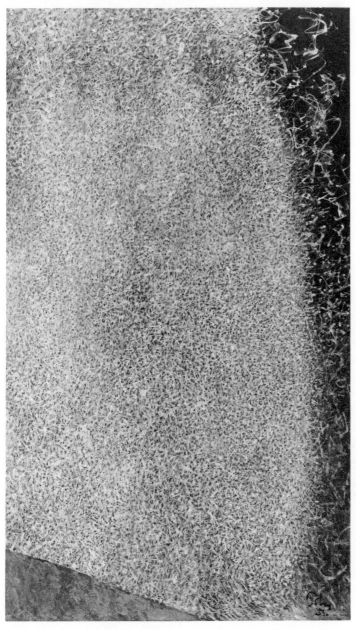

Mark Tobey, "Edge of August." Casein on composition board, 48 x 28 inches. Collection, The Museum of Modern Art, New York.

Jean Dubuffet, "Beard of Uncertain Returns." Oil on canvas, 45¾ x 35⅛ inches. Collection, The Museum of Modern Art, New York. Mrs. Sam A. Lewisohn Fund.

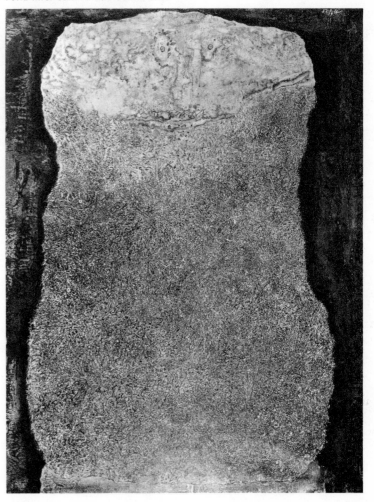

Tobey's "Edge of August" was executed with a long, thin-bristled brush in a calligraphic manner. The strokes move from the left to the right side of the composition, where they seem to detach themselves from the main shape, turning into drifting filaments that float into an empty darkness.

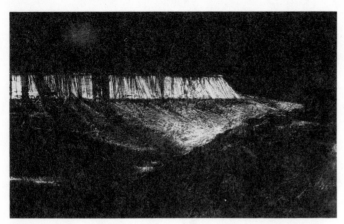

Joseph Mugnaini, "Chalk Cliffs near San Miguel" (Mexico). Oil glazes over lead and zinc paste, 48 x 60 inches. Collection of Mr. and Mrs. Richard Robinson.

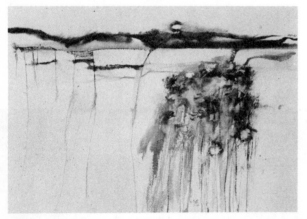

Albert Porter, "Landscape Mood." Watercolor, 22 x 30 inches.

My own "Chalk Cliffs" is a remembered view; Albert Porter's "Landscape Mood" is derived from imagination. Notice how Porter's watercolor resembles a detail from the upper rim of the chalk cliff in the oil painting. "Chalk Cliffs" represents the extreme contrasts of Mexico. It is not an actual landscape but was suggested by a fleeting view from a speeding automobile, sketched from memory, and completed later.

"Landscape Mood" closely resembles an Oriental sumi (brush-and-ink) painting. The search for an image is justified by an extraordinary display of sensitive brushstrokes, which are coincidentally similar to the structured verticals in "White Cliffs" on page 90,

as well as to those in "Chalk Cliffs." In Albert Porter's image, one feels that the artist is celebrating nature. In mine, I definitely used the contrast of the chalk cliffs to the surrounding darkness to symbolize the mood I was in when I painted it.

The pity one feels for the helpless has been symbolized innumerable times. What is more sorrowful than the death of the innocent? I feel this in all three of the works opposite.

In Soutine's "Dead Pheasant" the subject seems subordinated by the deft, intense handling of the medium. Note the brisk, calligraphic impressions representing the feet of the dead bird. Death was harshly familiar to Soutine. His statement was unequivocal.

Albert Pinkham Ryder's "Dead Bird" appears to be an underpainting because the tonal contrasts applied by glazing which normally mark Ryder's work are not evident. Even in this seemingly unfinished painting the delicate handling of the material which shapes the forms bears the impression of the artist's mysticism. For Albert Pinkham Ryder death held a certain fascination. Its shadow touched all of his work. For him it was perhaps symbolic of a long sleep—an unending dream.

Doris Thompson's "Dying Bird" is resolved in an individual manner in which line is as important as the subject. It seems strange that many of the dead-bird images I have seen are placed in this position, head to the left, tail to the right. Doris Thompson has explored the shape of the bird and in so doing questioned the enigma of death.

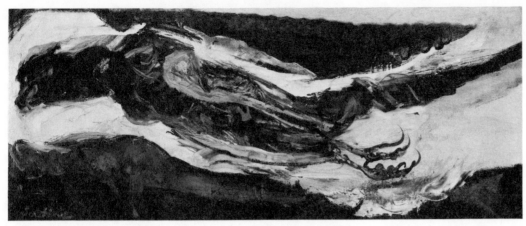

Chaim Soutine, "Dead Pheasant." Oil on canvas, 11¾ x 29½ inches.
The Phillips Collection, Washington, D. C.

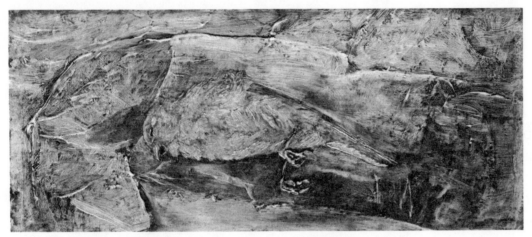

Albert Pinkham Ryder, "Dead Bird." Oil on wood panel, 4¼ x 9⅞ inches.
The Phillips Collection, Washington, D. C.

Doris Thompson, "Dying Bird." Pen and ink.

14 Shape in the History of Art

Before commenting on contemporary art I must say that social environment has always influenced the individual artist just as the artist has influenced his environment. Perhaps by scanning past art and history we can assess the influences of society on the young artist of today.

If it were possible to compress the culture of any historical period into a single representative work of art we would, by logical investigation of the image, method, and material used, be able to reconstruct an acceptable idea not only of the artist who produced it but also of his cultural climate.

Following this line of thought, I have devised an exercise which has helped many of my students comprehend the significance of art in history. The premise is simple: If by evaluating surviving artifacts we can reconstruct a segment of history, we can also imagine ourselves in the environment of that period, and, assuming the role of an artist, produce a work consistent with the time.

For example, a look at one of the early dynastic periods of Egypt would reveal (1) that the Egyptians were the greatest builders in history; (2) that they developed a culture in which art was dominated by architecture; (3) that their graphic art was relegated to the embellishment of architectural design, and painters restricted to a conventional, utilitarian imagery that was either supplied by or approved by the ruling oligarchy as well as the architect; (4) that in order to integrate his conceptions with the prevailing structural and decorative motifs, the artist engraved outlines of his designs into various surfaces and then either stained or painted them at a later time; and (5) that perspective and proportion were standardized to conform with the religious and secular symbolism.

Now let us select a familiar object to represent form in general and then interpret it in a style consistent with a culture of the

past, in this case an early period in Egyptian history. The object we select could be a common pear, for it possesses both symmetrical and asymmetrical aspects which could be exploited by an artist who required either or both of these qualities.

At right is a sketch of the pear as it would be painted by an Egyptian artist such as the one who designed the Palette of King Narmer.

I have used two pears, one to represent an important figure such as the Pharaoh, the other a figure of minor importance. The visual element employed is line, with the normally dissimilar halves of the form reduced to a rigid symmetry and the top and bottom of each set into a combined perspective.

I suggest that the reader continue this exercise, using the pear as subject matter, and interpreting its form in each of the following styles: Paleolithic, Greek, Byzantine, Renaissance, Baroque, Romantic, Realistic, Impressionistic, and Cubist. In this chapter I give my own interpretations, which are suggested only to help the reader develop his own versions. The tracings are to assist him in identifying reproductions which he can find in reference books on art.

Tracing of Palette of King Narmer from Hierkonpolis, about 3100 B.C.

It is obvious that to equate paleolithic art with crudity is a fallacy. The wounded bison could only have been conceived by a being *at least* as intelligent as we are. The sophisticated organization and control of visual elements and the subtlety of composition suggest·that a pear, like a bison, would be appreciated for its natural appearance but viewed as an object to be stated in curvilinear design.

Tracing of Wounded Bison
(cave painting), c. 15,000-10,000 B.C.),
Altamira, Spain.

133

Tracing of interior of an Attic red-figured kylix (c. 490-480 B.C.)

The Greeks believed that the visual appearances of things in nature are imperfect manifestations of a universal ideal. Any particular object or form only implies the perfection of the ideal model. To arrive at the idea of a perfect pear, an artist might study the best aspects of all existing pears and synthesize them into a work of perfectly balanced proportions.

In 313 A.D., Christianity, which had existed as one of many Oriental cults, was officially recognized by the Roman Empire. The later fusion of Eastern and Western culture stimu-

Tracing of reproduction of Justinian and Attendants (mosaic, c. 547 A.D., S. Vitale, Ravenna, Italy).

134

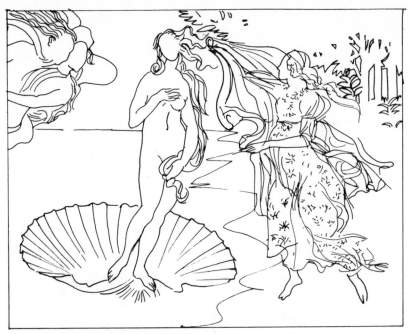

Tracing of a reproduction of Botticelli's "The Birth of Venus." Uffizi, Florence.

lated artists to incorporate Hellenistic simplicity with the opulence and formality of the Orient. In Byzantine style, the concept of the ideal pear would be gracefully elongated to conform with the rigid characteristics of Eastern symbolism.

Florence, unlike other major Italian cities, was not built upon a Roman town and did not possess a great number of antiquities to influence its emerging art. An artist was free to experiment, under the patronage of an enlightened oligarchy that encouraged a humanistic point of view. The pear painted in the style of Botticelli would be influenced by Greek classicism but modified by the artist's personal idiom.

In Europe the sixteenth and seventeenth centuries were a time of transition in which the growth of materialism conflicted with the spiritual and moral values of the Counter Reformation, like an encounter of opposing weather fronts. The resulting turbulence was reflected in all the arts of the period. At its best, Baroque art was powerful and eloquent. At its worst, it was exaggerated and melodramatic. I have interpreted a Baroque version of a pear as an amplified version of classical styles amalgamated with a humanistic view.

Tracing of reproduction of Guido Reni's "Aurora" (1613, Casino Rospigliosi, Rome).

Tracing of reproduction of Géricault's "The Mounted Officer of the Imperial Guard" (1812, The Louvre, Paris).

Romantic art is personal and expressive, glorifying not only man and his achievement but his environment as well. The intellectual climate of the eighteenth and early nineteenth centuries was one of interest in the common man and the rewards of natural aspiration. A pear would still be conceived in its classical shape and would be set in an environment no less idealized.

Tracing of reproduction of Courbet's "The Stone Breakers" (1849).

Tracing of reproduction of Monet's
"The Grand Canal, Venice" (Museum of Fine Arts, Boston).

138

The burgeoning of industry and a trend toward liberalism in the nineteenth century laid the foundation for an art that paralleled the literature of such writers as Emile Zola and Henrik Ibsen. The movement toward Realism could be considered a revolt against Romanticism in pointing out actual social problems. The pear could very well be presented as a decaying object, suspended from a blighted tree within a bleak and dismal landscape.

Impressionism extended Realism into the realm of color and light. The artist's concern was with the appearance of the object without regard for meaning. The shape of the pear would be secondary to its local color, the light reflecting from it, and its luminous environment.

Cubism stemmed from several sources, among them changes in scientific philosophy, the structural paintings of Seurat and Cézanne, and the experiments of Picasso. Picasso, influenced by the distorted imagery of African sculpture, began to dislocate his forms and reassemble them into angular shapes and planes in which solidity and space were equally important. Cubism, as a movement, was short-lived, yet its influence is still present.

A cubist would shape the pear into strong planes and sharp edges, revolving several aspects to make a single view.

Vincent Guerrero's collage is evidence of the influence of Cubism, which has also affected commercial design, from packaging to textiles.

As we proceed through the last chapter of this book, the reader might find it interesting to consider how each artist represented would render a pear as an expression of his own idiom.

Vincent Guerrero, ''City at Night.'' Collage, newsprint, ink and tempera, 18 x 24 inches.

15 The New

According to Shakespeare, "The purpose of playing…is to hold as it were the mirror up to nature—to show virtue her own image" (*Hamlet,* Act III, scene ii). Perhaps this is also true of art. But to understand the imagery of the artist we must realize that he denies the physical appearance of nature to achieve an illusive yet more significant reality. Shakespeare's comment could be extended to say that the artist holds the mirror up to nature hoping that the viewer will be surprised.

This endeavor can be misunderstood. From the most tyrannical of mistresses, the sense of sight, the artist must seduce an image which is too often measured by the amount of controversy it incites. The voices of dissension arise mainly from two sources: the sophisticated, who are reluctant to accept new imagery, and the uninitiated, who expect a work of art to be a visual replica of nature.

Art has always been in a state of flux, just like everything else. But perhaps it is particularly changeable today. In the isolated cultures of the past, a school or movement in art could develop slowly, mature, and perhaps eventually combine with other movements from other cultures. This is no longer possible. Modern communication, advanced methods of printing, and rapid distribution of material ensure swift dissemination of verbal and graphic descriptions of new works. A new global culture which has neither a specific location nor any ethnic or national characteristics is developing with great speed. International influences are supplanting what young artists term "archaic standards," standards that have survived from the Renaissance to the day of Abstract Expressionism. The result is a culture of the young which demands recognition.

Alan Zazlov, ''Running Men.''
Charcoal drawing.

Corinne West, ''The Scene.''
Pen, brush, and ink drawing.

Yet even though art may have new images reflecting an unsettled contemporary scene, its substance has remained essentially unaltered. The fundamental elements of art are still in common use. Moreover, in a sense, Romanticism, Expressionism, Classicism, Abstraction, Realism, Surrealism, and Cubism are as evident today, "after their time," as they were in their time and before their time, since art began. And new materials, regardless of their versatility, must still be manipulated and controlled; in spite of their exotic properties, they are still either opaque or transparent, rough or smooth in texture, fast or slow in drying time, rigid or malleable. Finally, human reactions to visual stimuli, which to a great degree determine the universality of art, are as they always were.

This, of course, leaves for consideration a major concern of this book: the intent or attitude of the artist. Let us look at the work of some artists who are trying to find new directions.

"Night Hawk" is a freely painted work in which the manipulation of the paint in both quiet and excited passages becomes an important factor. The strokes which shape the body of the bird seem to echo the predatory scream of a hawk.

Nina George, "Night Hawk." Oil on canvas, 42 x 48 inches.

Sally Fifer Bernstein,
"Trancas Tide." Watercolor.

Henry Miller, "Untitled."
Watercolor, Collection of
Mr. and Mrs. Jack Berger.

The poetry in Sally Fifer Bernstein's watercolor is expressed through its design and visual elements. The artist describes the metaphor she has so eloquently stated in paint: "In this particular painting the rocks that have been methodically washed ashore are the weighty objects and therefore the areas of thickest color applications and detail, while the kelp that is trying to tease them rhythmically back to the sea is light and ribbonlike." Watercolor is suited to this quiet, thoughtful painting.

A technical analysis of the Miller, Mesches, Berger, and Gillien (page 146) might read: "Two of the paintings are sharp-edged with extreme tonal contrasts, while two are softly contoured and fused into the surface." An insight into their imagery, however, is much more difficult to attain, for it involves an analysis of the more subtle and illusive factors of design.

The design of Henry Miller's watercolor seems to force us into the picture plane, not as a viewer, but as a participant. The technical device used to accomplish this was described on page 50.

Arnold Mesches's "Girl with Blue Hair" is also a typical example of controlled composition. The contemplative, introverted mood is enhanced by compressing the brushwork and design into a compact shape.

In contrast to the Miller watercolor, we seem to be totally detached from the event in Pat Berger's "Sunday in Sesto Fiorentino." The figures are strongly grouped and isolated against an indefinite background.

Arnold Mesches, "Girl with Blue Hair." Acrylic and oil, 60 x 40 inches. Collection of Mr. and Mrs. David Frees.

Pat Berger, "Sunday in Sesto Fiorentino." Oil.

Ted Gillien, "Ready for Work." Charcoal, 20 x 15 inches.

The charcoal drawing by Ted Gillien is one of a series based upon his family background. The figures seem to materialize, then dissolve into the background like a memory that is difficult to recall.

Joy Thornlay Hankins's painting is dark but not somber. It could very well typify a modern version of Romanticism, glorifying not a military hero, a victory, or a historical event but an ordinary condition of life. The figures of the woman and the dog, both momentarily occupied, yet moving toward the edge of darkness, present an image of solitude.

Martha Lek had no intention of representing physical reality. This is a study for a painting done in drypoint, very carefully executed, yet reflecting the illusive imagery of a somber dream.

Joy Thornlay Hankins, ''Circle of Darkness.'' Oil on canvas, 28 x 60 inches.

Martha Lek, study for a painting. Pencil and ink, 8 x 12 inches.

Ray Bradbury, "The Halloween Tree." Oil on canvas, 24 x 36 inches.

Kero Antoyon, "Three Graces." Oil on paper, 18 x 34 inches.

In contrast, Ray Bradbury produces an image with the quality of a childhood fantasy.

Kero Antoyan's "Three Graces" was done as a classroom demonstration using transparent oils over a charcoal drawing. Compare the romantic quality of this image with that of Robert Vickrey's "Labyrinth" on page 54.

The original of "Kansas Overflight" is only slightly larger than the reproduction. Inspired by viewing the landscape while in flight, it is a masterfully balanced composition in which only a slight modification would destroy the equilibrium. Texture and shape are merged into a compelling three-dimensional fantasy. The choice of material is important.

148

Philip Van Brunt, ''Kansas Overflight.'' Collage, 12 x 12 inches.

Dorothy Merk has used line not only to construct an image but also to combine a quasi-naive manner with one that is highly sophisticated, which intellectually teases the viewer. This could have been executed in various materials without losing its character.

How can one visually describe the inertia and solitude of those who find themselves old and alone? Sam Clayberger selected a middle tone scale, placed his figures in twilight shadows, then drew and shaped an inner view which perhaps would not correspond with what seems obvious or real to others.

In Vilan's "Tumbril" we feel that the cart which is temporarily blocking our view will soon move on, exposing the remains of a sinister event. Ink was brushed over dried oil colors and channeled into predetermined areas by tilting the canvas in various positions.

Dorothy Merk,
"Drawing." Mixed media.

Sam Clayberger, "The Grey Men." Pencil, ink, wash, and acrylic, 8¼ x 10 inches.

Demetrios Vilan, "Tumbril." Oil and India ink over gesso, 18 x 21 inches.

The design of John White's painting is an intriguing dichotomy in which recognizable forms are opposed by the abstract pattern, which seems alternately to penetrate into the picture plane and to deny it altogether. The shape and design of this painting is its own subject matter.

John White, "Untitled." Oil on canvas, 4 x 5 feet.

Of "My Dear Miss Marjorie S" the artist says: "The idea for this painting came from an old 1917 newspaper which I was using on a collage on canvas. It seemed to suggest men going to war who may have courted the girl in the newspaper photo and love letters which might have been written. The painting took on the image of a scrapbook which the girl might have kept. The suitors are symbolized by heads because we usually see faces when we remember people."

With a mordant satire comparable to that of Daumier, Cecily Grossman questions the values of middle-class tradition. Robert Wendell's parody on a portrait (one of a series of paintings based on themes of the Civil War) probes the nation's conscience. Wendell's material is oils, used directly with linseed oil as a medium.

Louis Ott,
"My Dear Miss Marjorie S."
Collage, oil and graphite.

152

Cecily Grossman, "Untitled." Oil on canvas, 48 x 24 inches.

Robert Wendell, "Painting." Oil on canvas.

Adrian van Suchtelen explains: "This drawing borders on becoming a painting. It deals with an interpretation of the Crucifixion with the figure reduced to a mutilated torso and the cross to horizontal and vertical lines."

The collage has been used for centuries, by many artists, including Rembrandt, to correct or develop designs. In this case it is used for its own sake, allowing the artist to change and probe areas of his composition quickly without premature commitment.

Gary Lloyd's "Study for Design" is an excellent example of using the visual elements of line, tone, and space for purely aesthetic purposes in which they become their own subject matter.

Stephanie Lipney employs a graphic metaphor using oddly shaped forms and textures which focus upon the absurdities of modern society. The materials themselves contribute to this tour de force.

Adrian van Suchtelen, "Christian Torso." Mixed media.

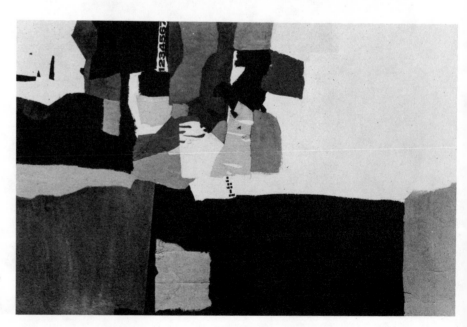

Frank Cheetham, "Collage." Mixed media. Collection of Mr. and Mrs. Otis Chandler.

154

Gary Lloyd, ''Study for Design.'' Mixed media.

Stephanie Lipney, ''Pun.'' Oil and fabric collage on Masonite, 48 x 40 inches.

Mary Lynn Dominguez, "The Domestic." Colored pencil and acrylic, 4 x 6 inches.

Saul Bernstein, "Banquet on the Mount." Oil on canvas.

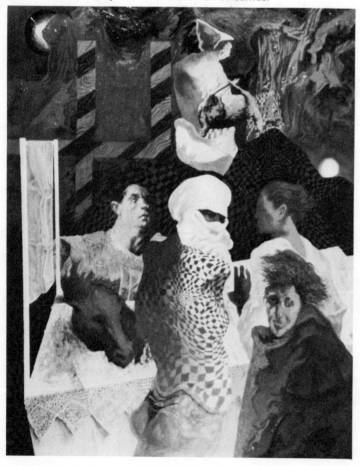

Mary Lynn Dominguez: "I build my image very slowly, finding that color pencil is a good medium for this way of working. When I use them on canvas board I can produce a variety of colors in various densities. In this painting the shapes made by the pencil are intensified by solid background in which I also used acrylics."

Saul Bernstein's "Banquet on the Mount" was inspired by a musical composition, "Night on Bald Mountain," by Modest Mussorgsky. "The people are assembled at the banquet table, aching for a taste of the sacrificial lamb, but alas no results—for they possess no arms and hands with which to eat. The only hand comes from the feminine form in the painting—the hand of hope. The initial stages of the painting dealt with music ratios and precise abstract shapes which relate with this particular piece of music. Then, with the help of Goethe's color theory, I began to mold my total image. Through the many checks and balances I hoped to produce a recognizable psychological piece."

Joseph Ferris comments: "The wet-in-wet method of oil painting demands that I rely on my intuitive powers rather than on contrived preliminary drawings or conceptions. The image comes out of the paint and my disposition at the time. It all happens very fast and is the only way of making the painting a living event for me. My work is based on mood and intuition; the object is unimportant, the value is in the experience of responding."

Peter Liashkov describes his own painting as "an almost schematic interplay of preconceived textural planes for their own sake."